5·23·11

56320

Andy Warhol

Andy Warhol
Unexposed Exposures

edited by Bob Colacello

SteidlKasher

He Got The Picture
By Bob Colacello

Photography is an essential ingredient—one might even say *the* essential ingredient—in all of Andy Warhol's work, from his paintings, drawings, prints, and sculptures to *Interview* magazine and most of his books. Arguably, Warhol did more than any other 20th-century artist to legitimize photography as a fine art form, by employing it in such an unabashed, matter-of-fact, and crucial way as the basis for his most important 1960s paintings, including the *Marilyn*, *Liz*, *Electric Chair*, and *Death and Disaster* series. What *is* a Warhol portrait, at its root, if not a colorized photograph? Warhol's early experimental films, such as *Sleep* and *Empire*, are in effect black-and-white photographs extended over several hours with almost no movement.

Warhol's involvement with photography goes back to his childhood in Pittsburgh, when at the age of eight he was afflicted with Saint Vitus's dance, a rare disease of the nervous system. During the ten weeks Andy spent in bed, his brother Paul helped him write fan letters to Hollywood stars, requesting autographed photos—Shirley Temple was his favorite. This became the first of the many collections Andy would eventually amass, from cookie jars to Art Deco jewelry and Navajo rugs. He also continued collecting photographs. When I was the editor of Interview, a Special Photography issue in 1975—with a cover line asking "Is Photography Art?"—included a Man Ray study of a man's back, which had been loaned to the magazine by an anxious Warhol. *He* obviously considered it a *valuable* work of art, for he must have told me at least 20 times to "be careful" with it, emphasizing that Man Ray was his favorite photographer. Among the scores of photographs in the weeklong auction of Warhol's possessions that Sotheby's mounted after his death were images by Muybridge, Curtis, Steichen, Weston, Cecil Beaton, George Hurrell, George Hoyningen-Huene, Horst, Irving Penn, and David Bailey.

According to Paul, the oldest of the three Warhola boys, he gave his little brother his first camera when he recovered—a Kodak Brownie—and Andy loved taking pictures of the family, their backyard, and neighborhood friends. Although Andy claimed their middle brother, John, "threw out" most of his things, including works he did in high school and as a Painting and Design major at the Carnegie Institute of Technology, when their parents' house was sold, some of these early Kodak pictures survived and are in the archives at the Andy Warhol Museum.

But, as far as is known, Warhol didn't take pictures again until 1968, when he acquired his first Polaroid. By then he had become world-famous for his icon-like silk-screens of Hollywood movie stars, but these were based on publicity stills. Paintings such as 1963's *Green Car Crash*, as well as the portraits of Jackie Kennedy at her husband's funeral, appropriated newspaper photos. And Warhol's lifting of a photograph of hibiscus blossoms from *Modern Photography* magazine for his 1964 *Flowers* paintings led to a lawsuit by the original photographer and a settlement. All of these works were manufactured at the infamous "silver" Factory on East 47th Street, where the silk-screening, filmmaking, and partying went on around the clock, recorded not by Warhol himself, but by his appointed court photographer, Billy Name. Guests at these endless bashes would find themselves sitting in front of Warhol's movie camera and tripod for a three-minute *Screen Test*. More than any of his films, these silent, black-and-white, intensely intimate reels anticipate the arresting confusion of portraiture and reportage so characteristic of the 35-mm still photographs he would start taking in 1976.

When I met Andy in 1970, he was still carrying his Polaroid Big Shot in a plastic shopping bag wherever he went. This was the camera he used to photograph the subjects of his commissioned portraits, because it was specifically designed to take only close-ups. He would take it out at parties and shoot individuals he found interesting, but these impromptu sittings yielded straightforward, tightly framed portraits, with little or no sense of place, time, or scene. This all changed in February 1976. That month Warhol made one of his frequent art-business trips to

Europe, accompanied as usual by his manager Fred Hughes and me. In Zurich, the art dealer Thomas Ammann came by Andy's hotel suite with the just-released Minox 35EL, then the smallest camera to take full-frame 35mm photographs. "Oh, it's so great," said Andy. "It looks like a James Bond camera. Aren't you going to give it to me?" Ammann tried to buy one for Andy, but every camera shop in Zurich was sold out. Our next stop was Bonn, where we immediately went to a camera shop and bought two, one for Andy and one for me.

Back at the hotel, we both took the same first photograph: a still-life of a room-service cart bearing the remains of lunch. A day or two later in Naples, while we were taking matching pictures of the bay, Andy blurted out, "We should do a photography book together! We'll put your contact sheets on the left-hand pages and my contact sheets of the same things on the right-hand pages. It's a great idea." That was the genesis of *Andy Warhol's Exposures*, which was published in 1979. There were no contact sheets—"too corny" declared Andy—and all the photographs were credited to Warhol, although several were actually Colacellos. For me, in any case, photography was mostly an adjunct to my *Interview* party column, "OUT." For Andy it was one more way to obsessively record the time in which he lived, a visual counterpart to the private diary he dictated to Pat Hackett first thing every morning. A clue to the unspoken but serious artistic intent behind these photographs is that Andy withheld them from his own magazine, preferring to save them for books and limited editions.

From 1976 until his death, 11 years later, he took at least one roll of Kodak Plus-X or higher-speed TRI-X black-and-white film every day. Color, he said, was "too expensive," and it didn't have the paparazzi feeling he liked. Ron Galella, he often told reporters, was one of his favorite photographers—and he meant it. ("There's always something happening in Ron's photographs," he said. "It's not just two people standing there, like most party pictures.") Night after night, he'd set out for his round of art openings, movie premieres, book parties, dinners, and discos, his jacket pockets stuffed with extra rolls of film and

batteries. "It's work," he would say, of both his party-going and his picture-taking. He sent his film to a commercial laboratory to be developed, and once a week chose about 50 images from the contact sheets to be printed by Christopher Makos. A photographer himself, Makos printed Andy's photographs the same way he did his own, extremely high-contrast and rough-edged, giving it the "fast, easy, cheap, different" look Warhol sought in all his work.

Makos art-directed *Exposures*, and I wrote the text, with help from Brigid Berlin. We had wanted to title the book *Social Disease*, but our publisher, Grosset & Dunlap, objected, saying it wouldn't play at B. Dalton, then the dominant bookstore chain. Having a commercial publisher also influenced our choice of photographs: we wanted young beauties of both sexes and ladies whose husbands might have their portraits done; they wanted major movie stars and other names famous west of the Hudson River (and keep the still lifes of room-service carts down to a minimum, please). Some pictures were cut simply because we had too many images of certain Factory regulars, such as Bianca Jagger, whom Andy considered the greatest beauty of her time, and Truman Capote, who let Andy follow him everywhere, including to the office of his plastic surgeon. Many of the most interesting photographs were left out.

This exhibition spotlights that great unpublished body of work, including an entire suite of still lifes and a landscape of Andy's beloved McDonald's on Union Square West. It encapsulates the full sweep of Warhol's world, from William S. Burroughs to Chris Evert, from Gloria Swanson to the Talking Heads, from Amy Carter in the woods at Plains, Georgia, to Jade Jagger on the beach at Montauk. Some of the most significant images are of Andy's 60s leading Superstars a decade later: Viva with child, Brigid Berlin with boy toy, Nico in John Lennon specs, a pensive Lou Reed with New York Doll David Johansen. Also portrayed are the 70s employees and collaborators Andy used to fondly call "the kids": Fred Hughes, in black-tie, with the Brazilian socialite Elizinha Moreira-Salles; Jed Johnson, with Fred's ex-wife, Marina Schiano; Vincent Fremont, looking corporate; Chris

Makos, misbehaving; Barbara Allen, the most beautiful girl of her generation, in biker costume. In all these images, as in most of those in this exhibition, there is a sense of intimacy as well as of voyeurism, of funny-looking, insecure, wistful Andy, through flattery and attentiveness, trying to connect. Yet, because he was not just any photographer but a famous artist, a star, there is often a sense that the looking is being done *at* the man with the camera as well as by him. In some cases, the subjects are clearly performing for their fellow luminary, or close friend, or boss. As spontaneous as these images may seem, they are intrinsically staged, with Warhol himself as both chronicler and catalyst of the moments he is documenting.

And what moments they are! Only Andy could get David Hockney in extra-brief running shorts, or Susan Sontag batting her eyelashes across a fancy restaurant table at Gloria Vanderbilt, or Halston's Venezuelan window dresser and lover, Victor Hugo, sitting under Goya's *Red Boy* in Kitty Miller's Park Avenue parlor. Here's fashion designer Giorgio di Sant'Angelo smooching; Paloma Picasso spreading her hands to indicate the width of one of her father's paintings; Margaret Trudeau, Canada's First Lady, chatting up Milos Forman. Indeed, almost all the face cards of the late 70s scene are here, at ease behind the velvet rope: brash Steve Rubell and reticent Ian Schrager, Diane Von Furstenberg and Barry Diller with Henry Kissinger, Mick Jagger beside Catherine Deneuve, Roman Polanski, Diana Ross, Tatum and Ryan O'Neal, Liz Taylor deep in her Senator John Warner period, Arnold Schwarzenegger before politics, and O.J. Simpson when everyone still loved him. So are the footnotes of celebrity history: Elvis's ex, Priscilla Presley, with her Scientologist model boyfriend, and Ruth Kligman, the woman who was in the car with Jackson Pollock when he crashed it into a tree and was killed. And let's not forget—Andy didn't—Don King, boxing impresario; little Edie Beale, Jackie's batty cousin; Famous Amos, the cookie king, and Norman the neighborhood coke dealer, if your neighborhood happened to be the West Village.

Enough! You get the picture. Andy always did.

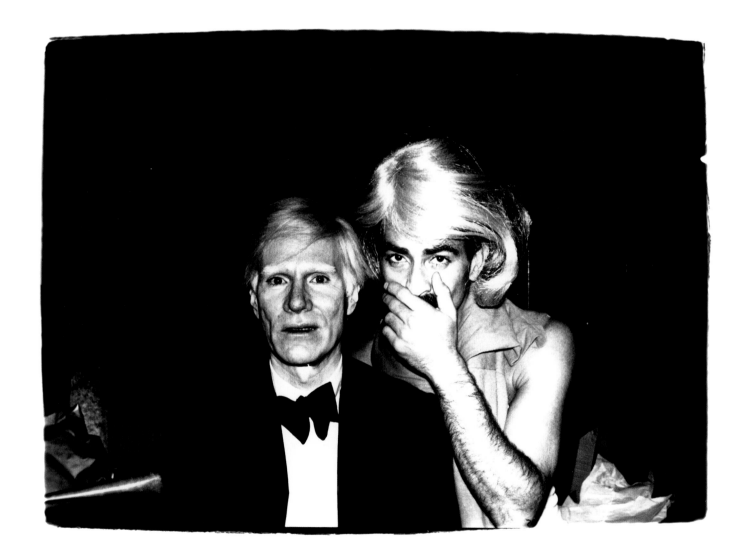

Andy Warhol and Victor Hugo, 1979

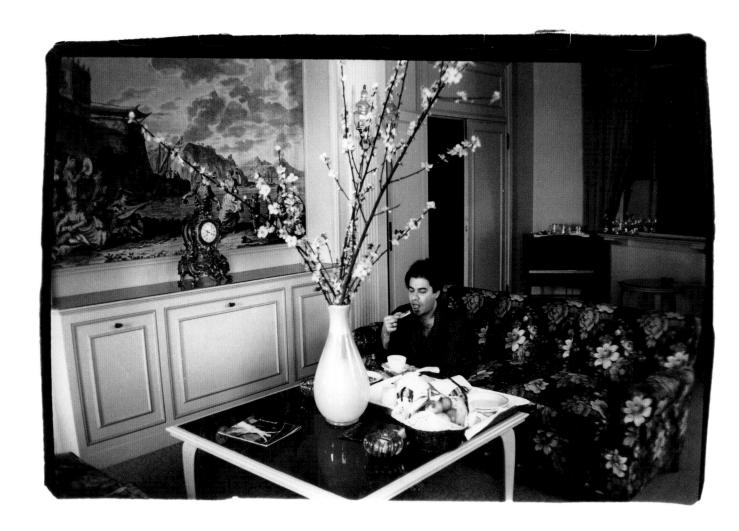

Bob Colacello, ca. 1976-79

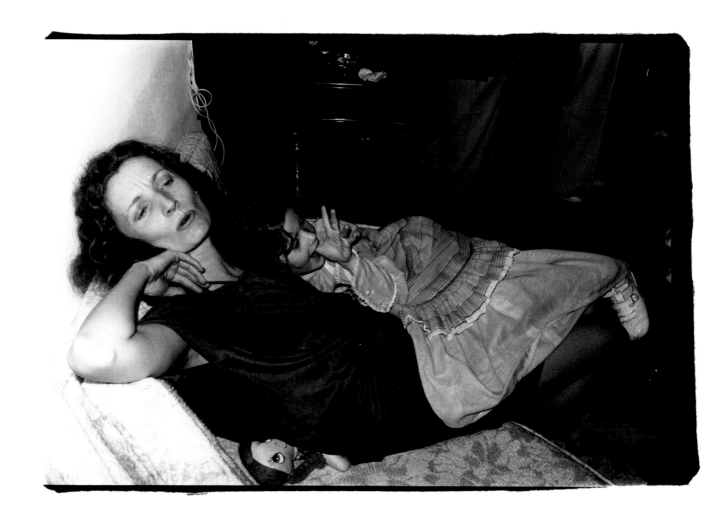

Viva and Unidentified Girl, ca. 1976-79

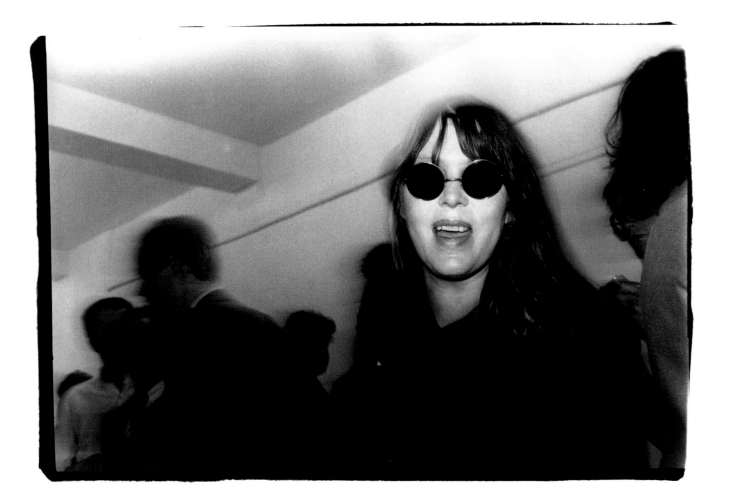

Nico, ca. 1976-79

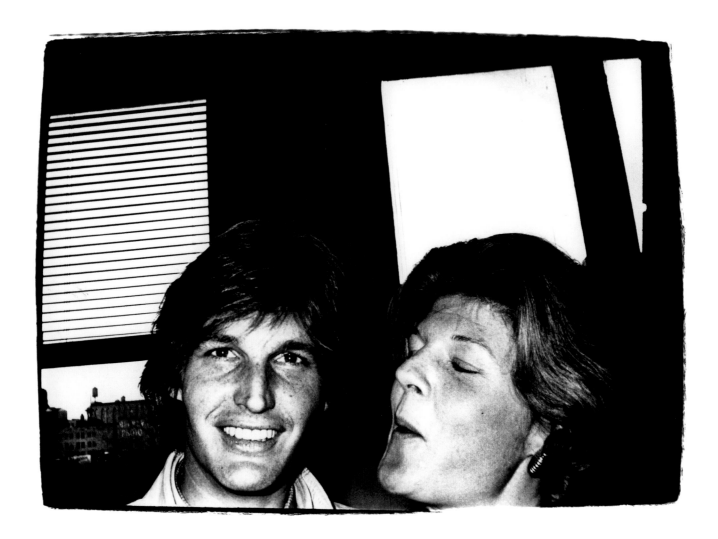

Brigid Berlin and Friend, 1978

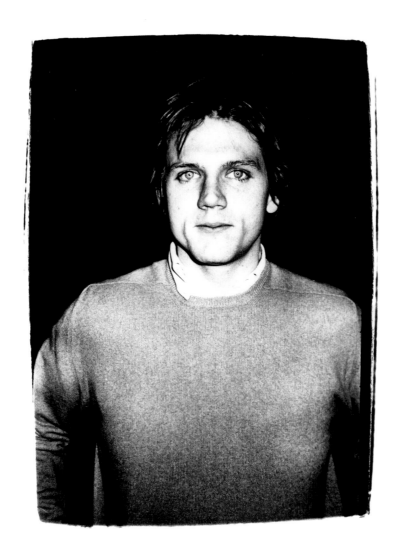

Richard Berlin, ca. 1976-79

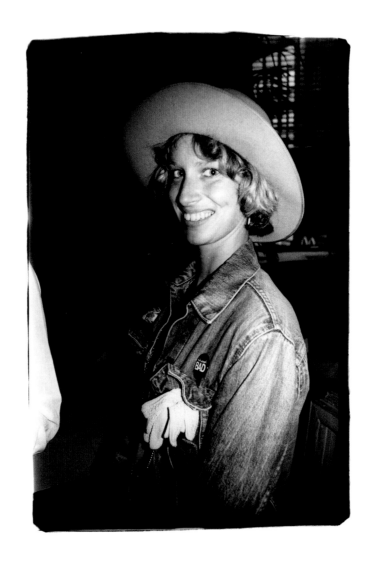

Donna Jordan, ca. 1976-79

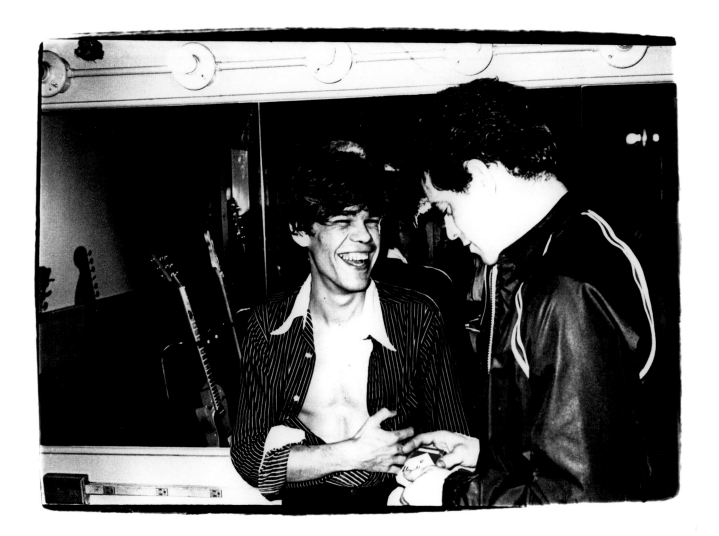

David Johansen and Lou Reed, 1978

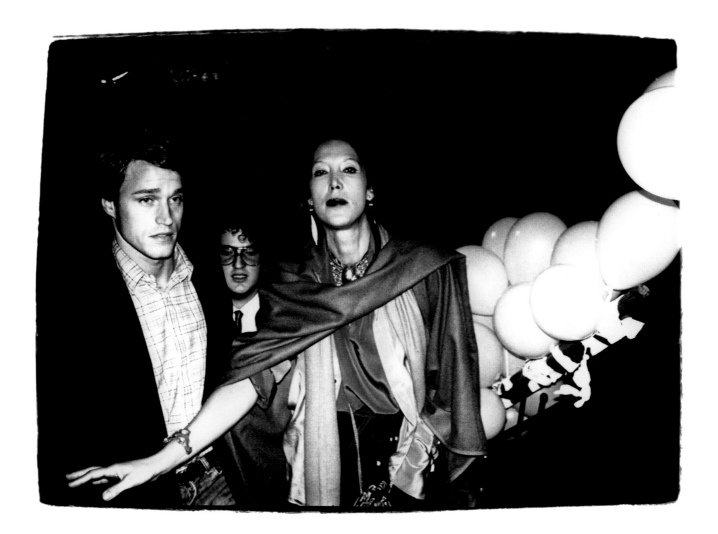

Jed Johnston, Hugo Jereissati and Marina Schiano, 1979

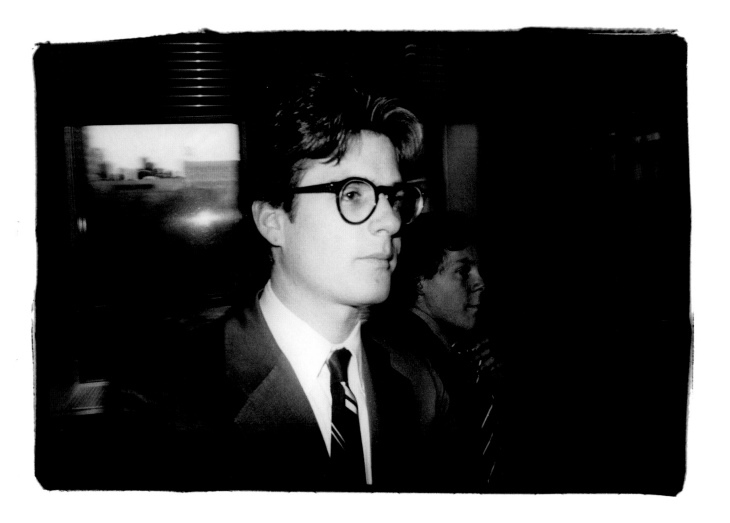

Vincent Fremont, ca. 1976-79

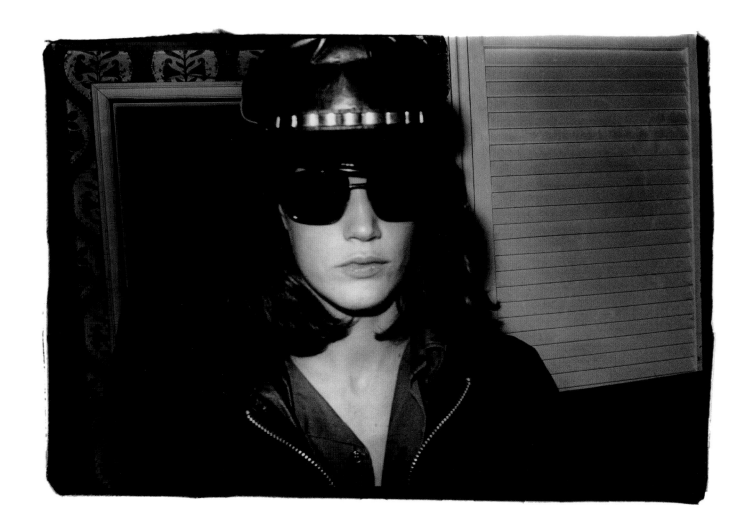

Barbara Allen, ca. 1976-79

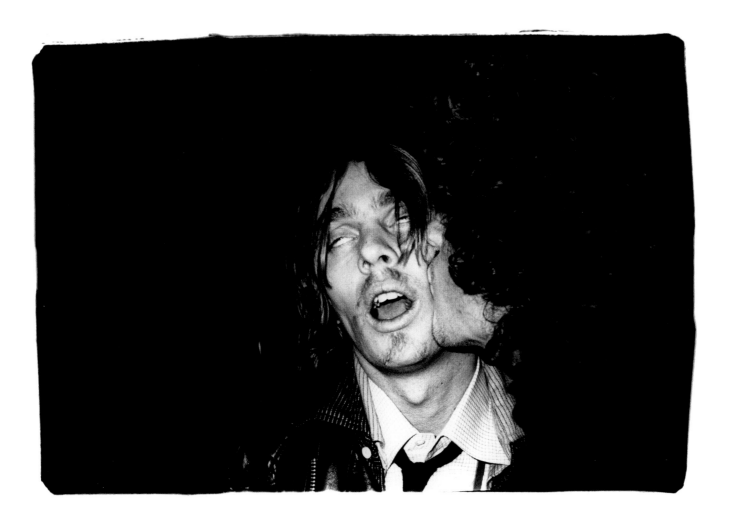

Chris Makos and Friend, ca. 1976-79

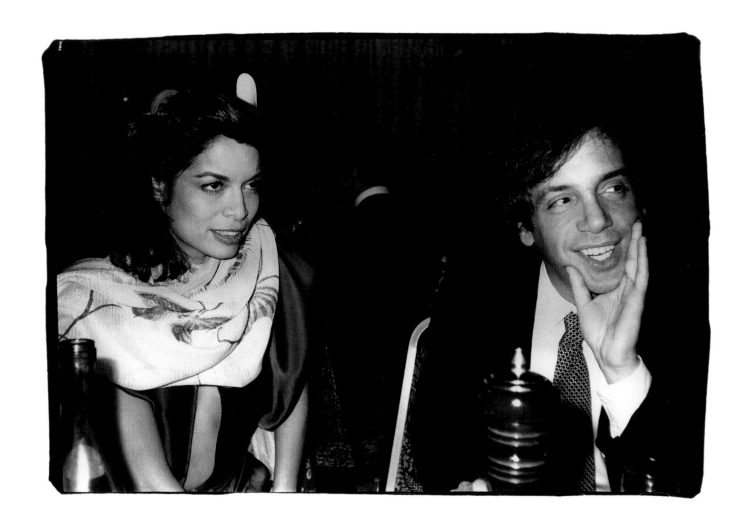

Bianca Jagger and Steve Rubell, 1978

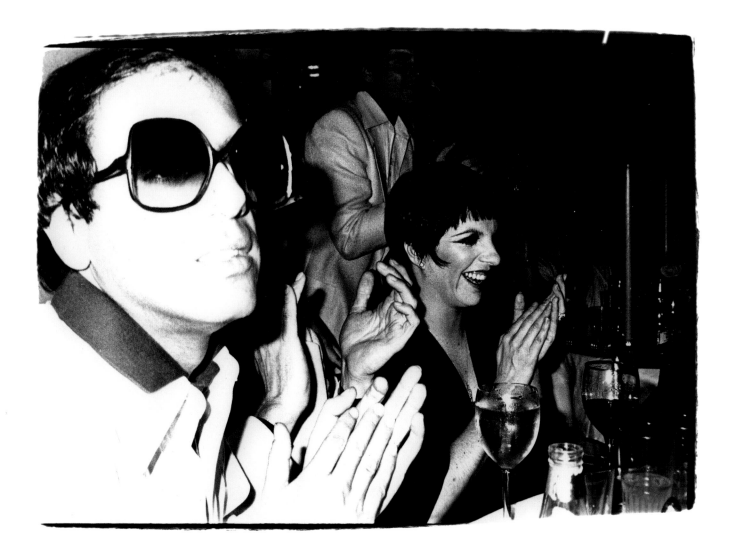

Steve Rubell and Liza Minnelli 1977

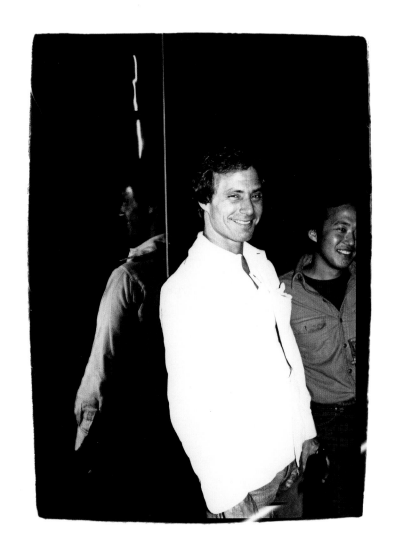

Ian Schrader and Fellow Partygoer, ca. 1976-79

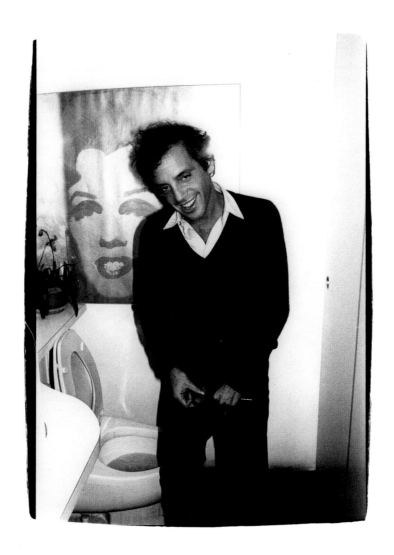

Steve Rubell, 1979

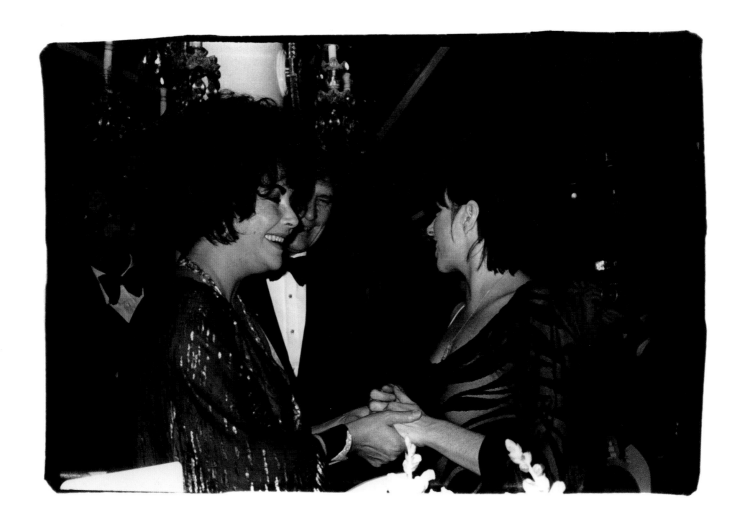

Elizabeth Taylor, John Warner and Liza Minnelli, ca. 1976-79

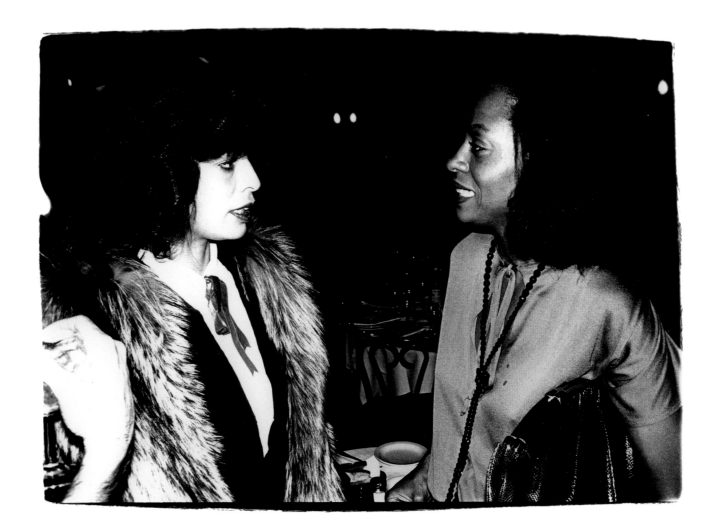

Bianca Jagger and Diana Ross, 1979

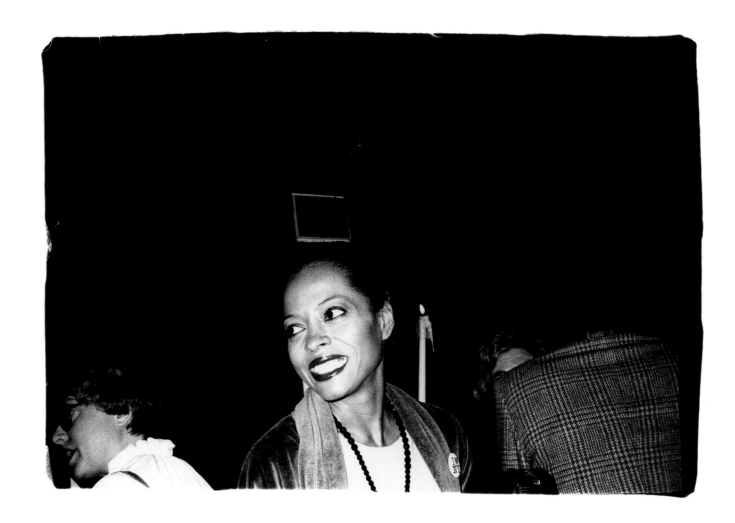

Diana Ross, 1978

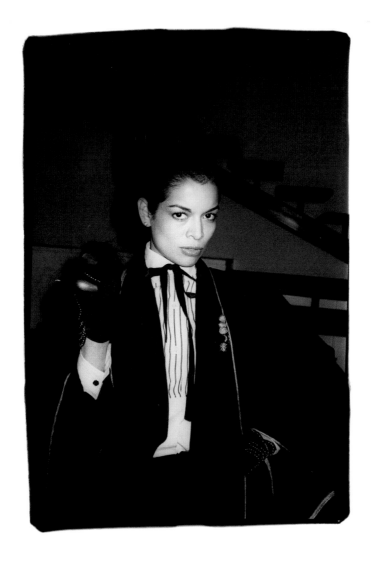

Bianca Jagger, ca. 1976-79

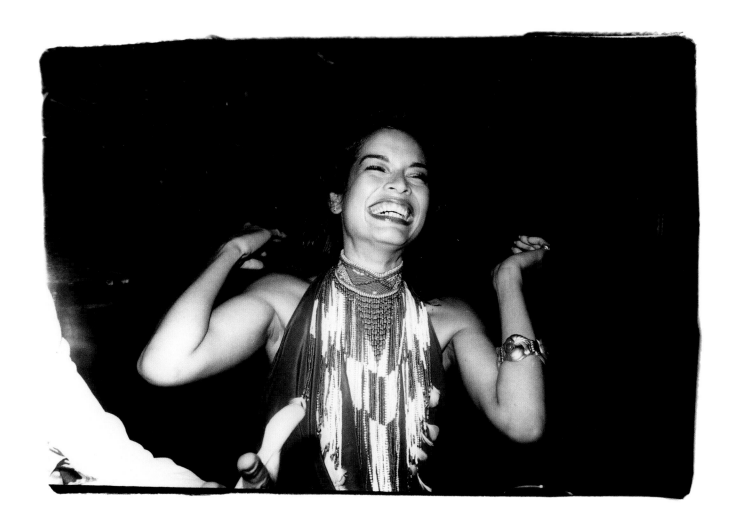

Bianca Jagger, ca. 1976-79

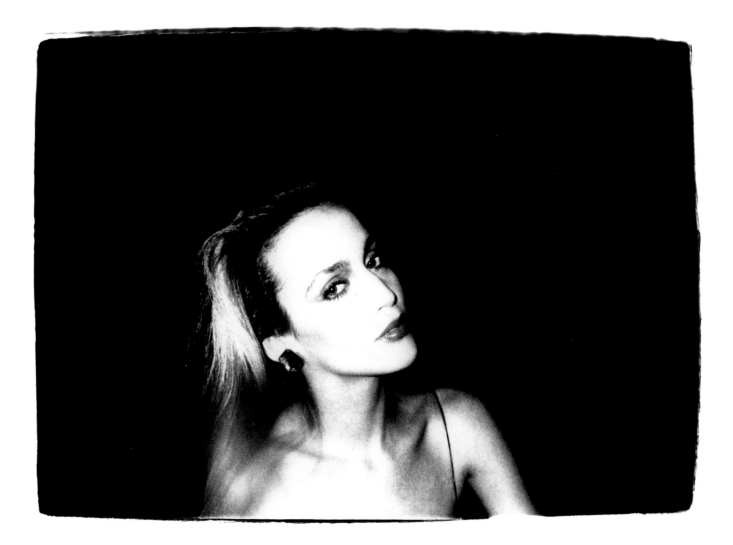

Jerry Hall, 1978

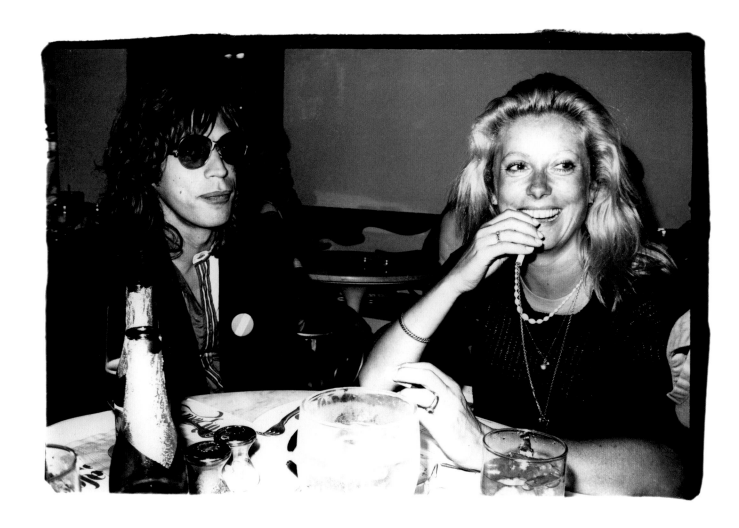

Mick Jagger and Catherine Deneuve, ca. 1976-79

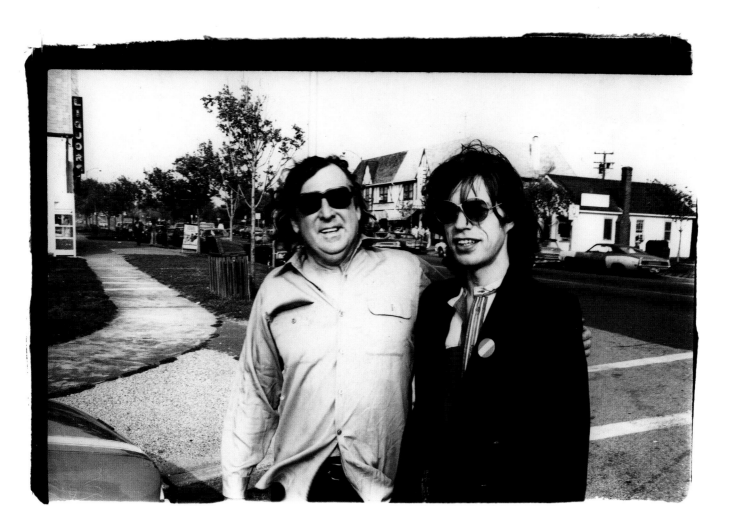

Terry Southern and Mick Jagger, 1976

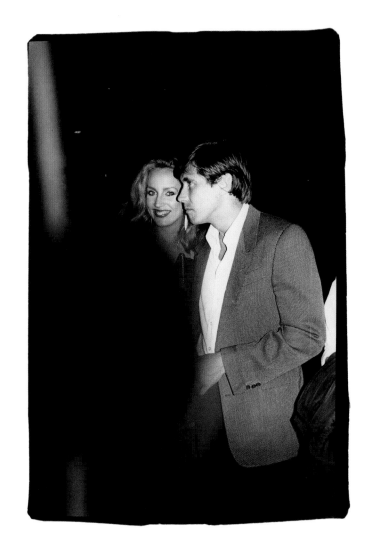

Jerry Hall and Bryan Ferry, ca. 1976-79

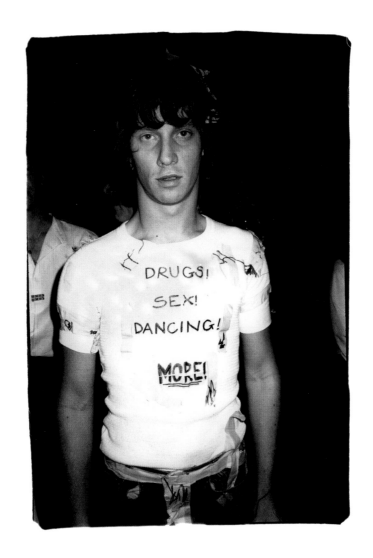

Studio 54, ca. 1977-79

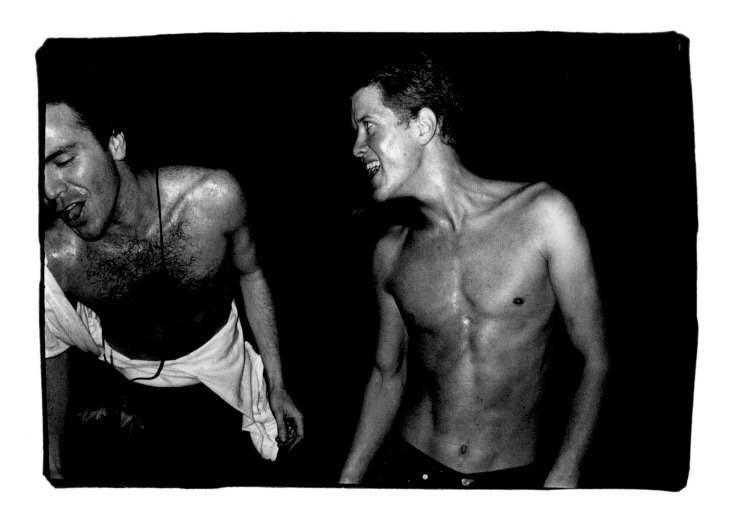

Studio 54, ca. 1977-79

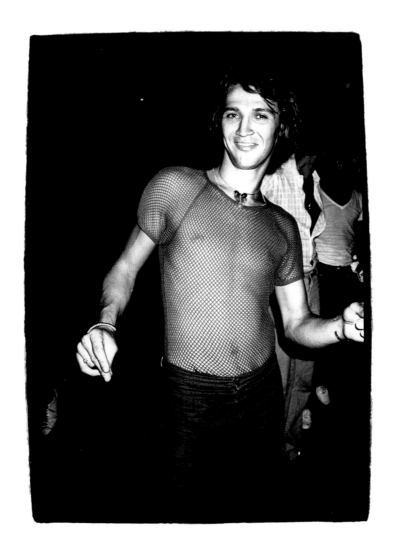

Studio 54, ca. 1977-79

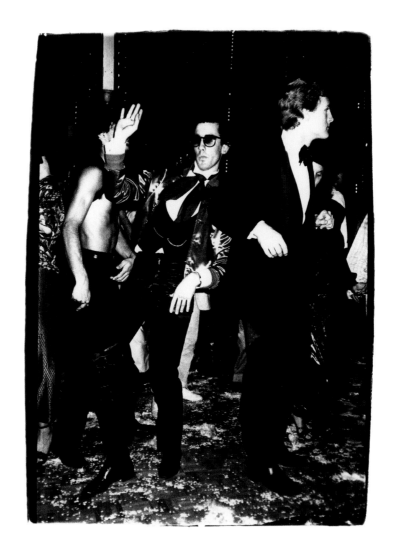

James Curley and Fellow Partygoers, 1978

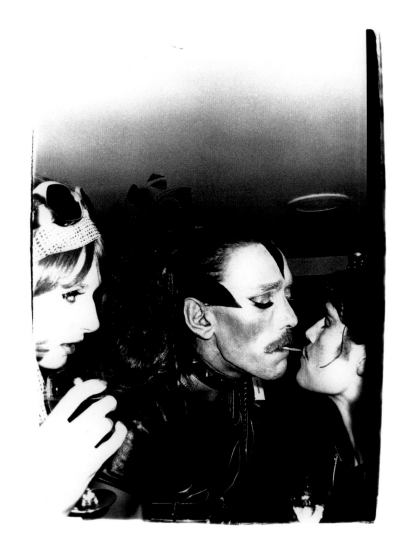

Studio 54, ca. 1977-79

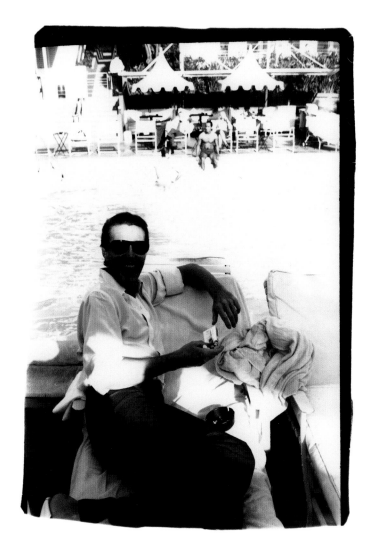

Halston, ca. 1976-79

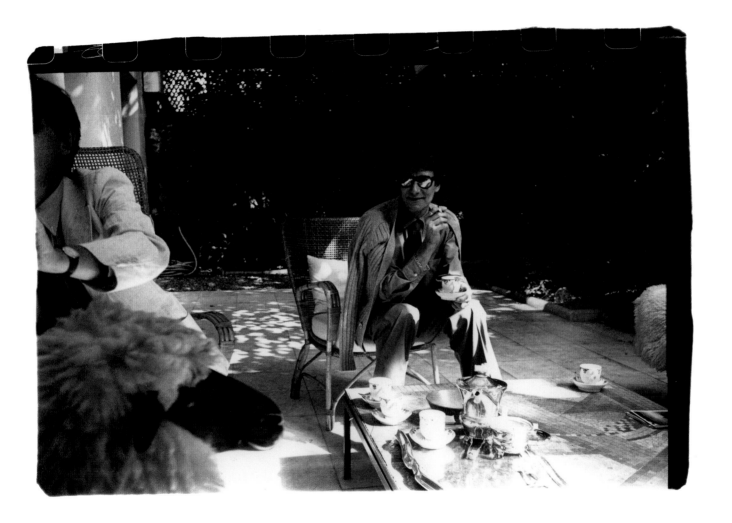

Yves Saint Laurent, ca. 1976-79

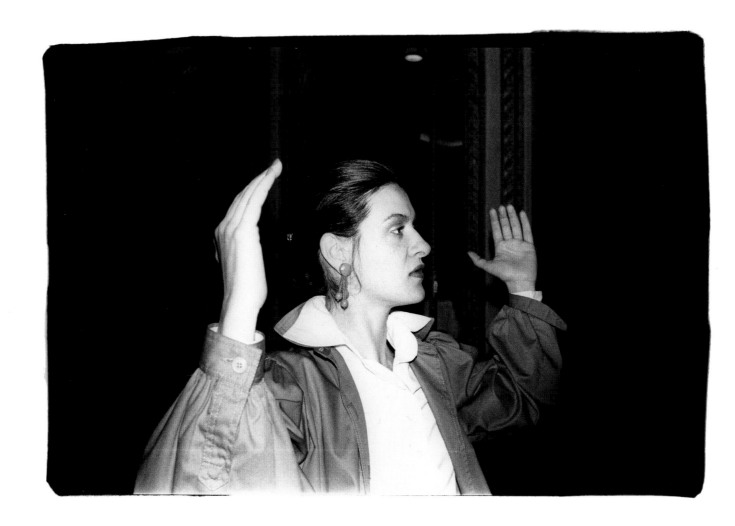

Paloma Picasso, ca. 1976-79

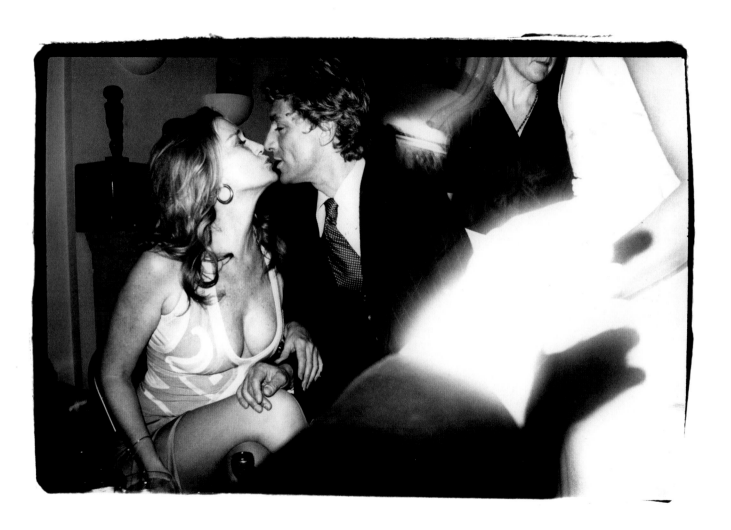

Giorgio di Sant'Angelo and Friend, ca. 1976-79

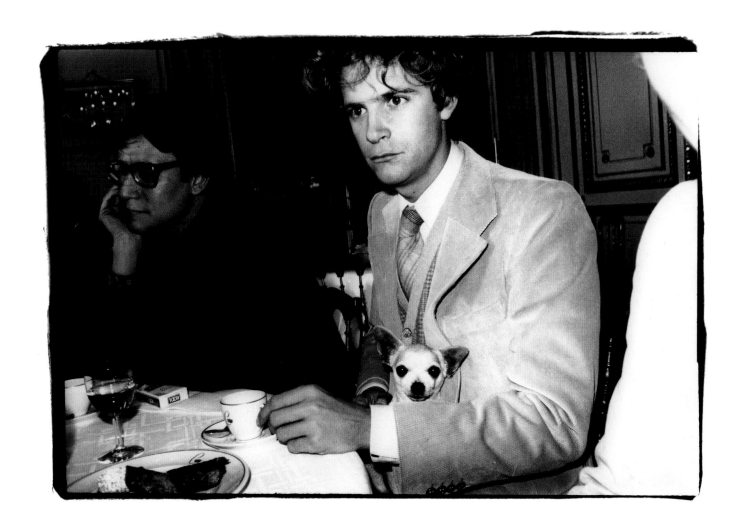

Yves Saint Laurent and François-Marie Banier, ca. 1976-79

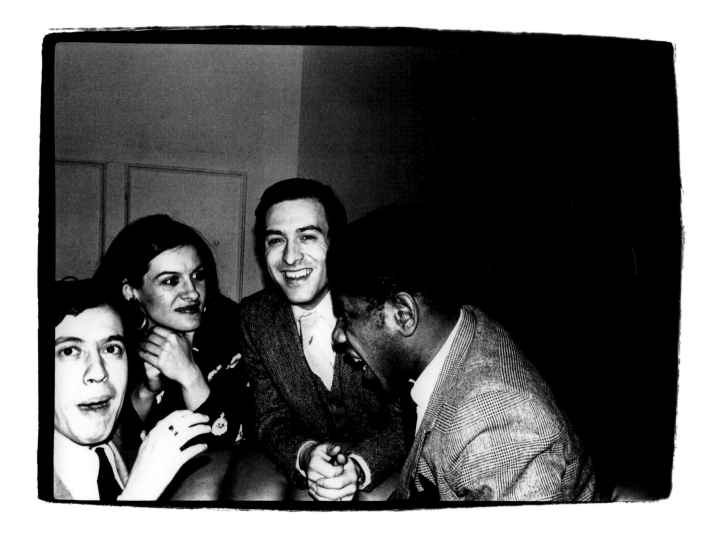

Javier Arroyuelo, Paloma Picasso, Rafael Lopez Sanchez and Andre Leon Talley, 1979

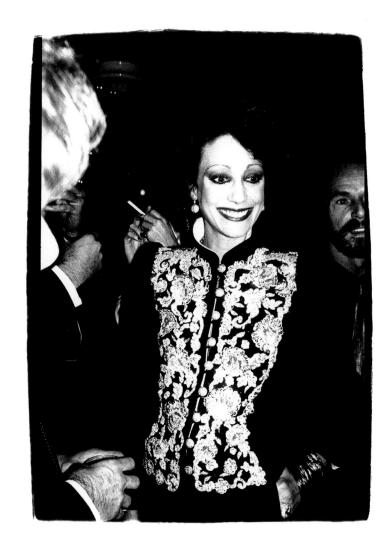

Marisa Berenson, 1979

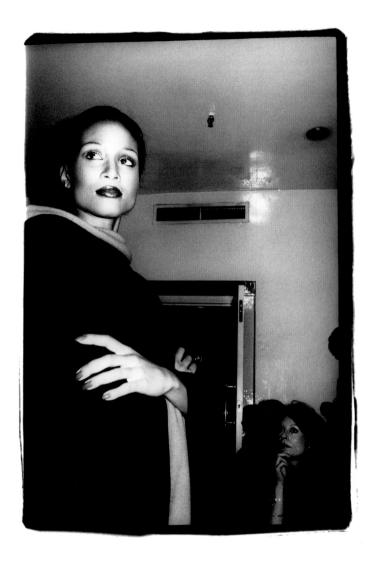

Beverly Johnson, ca. 1976-79

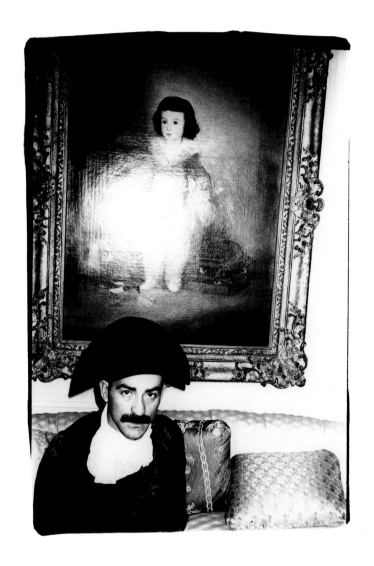

Victor Hugo, ca. 1976-79

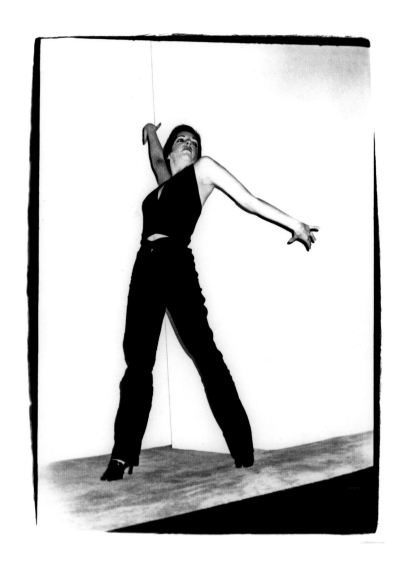

Liza Minnelli, ca. 1976-79

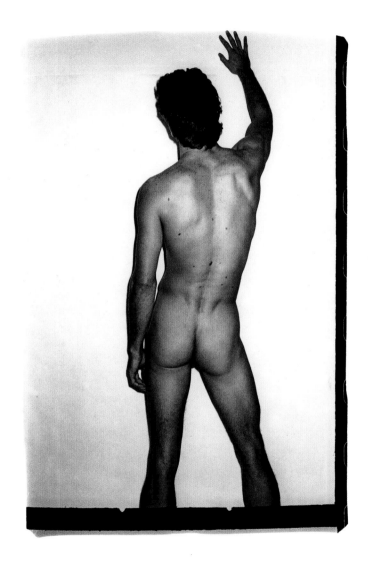

Torso, ca. 1976-77

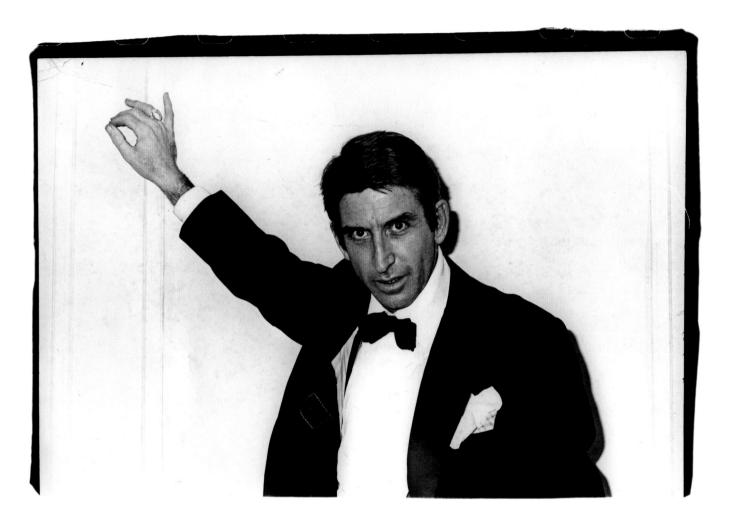

Norman Fisher, ca. 1976-78

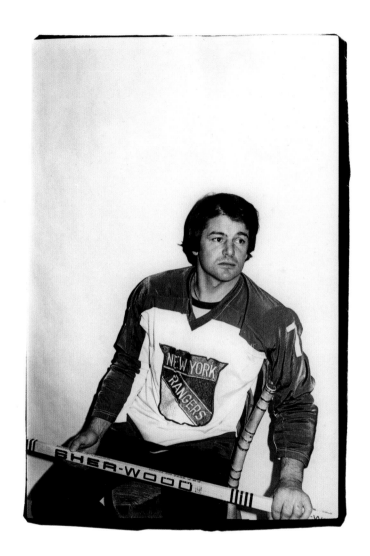

Rod Gilbert, 1977

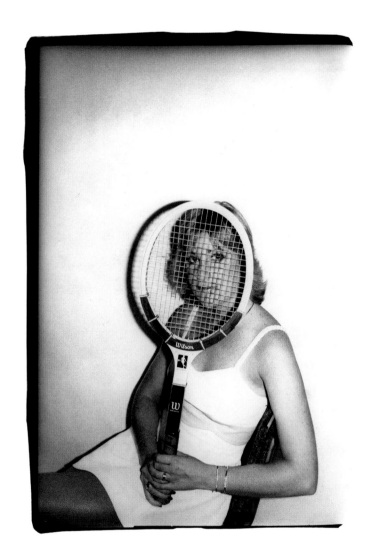

Chris Evert, 1977

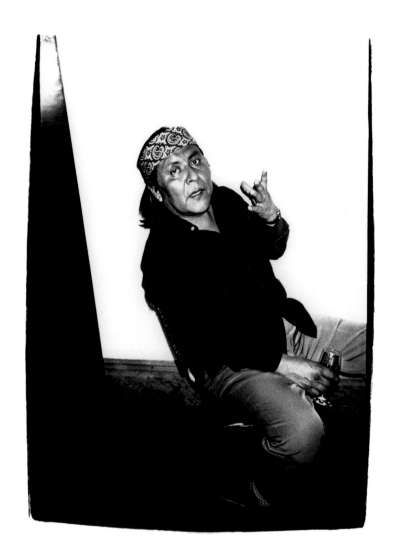

R.C. Gorman, 1979

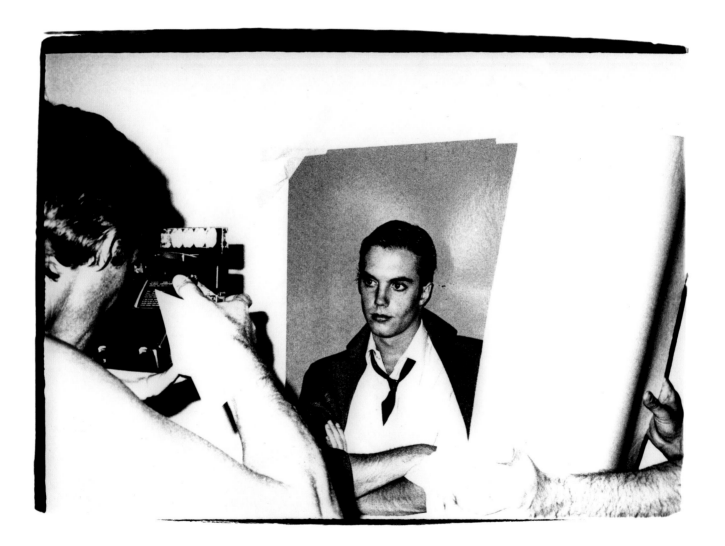

Shaun Cassidy, 1978

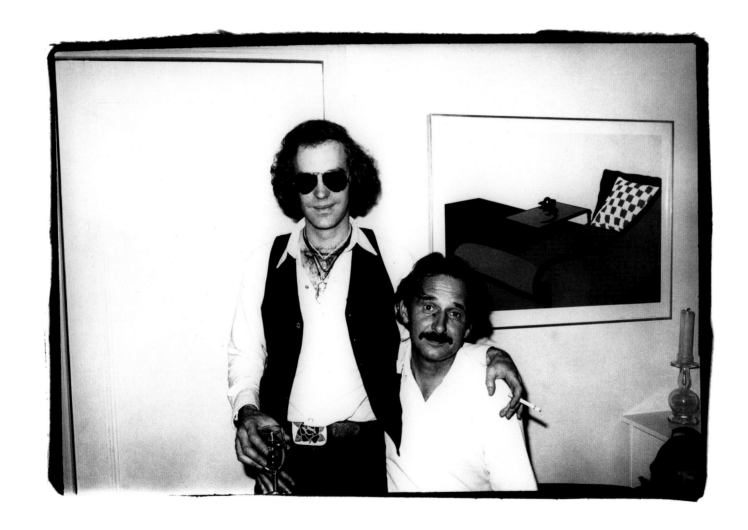

Francois De Menil and Earl McGrath, ca. 1976-79

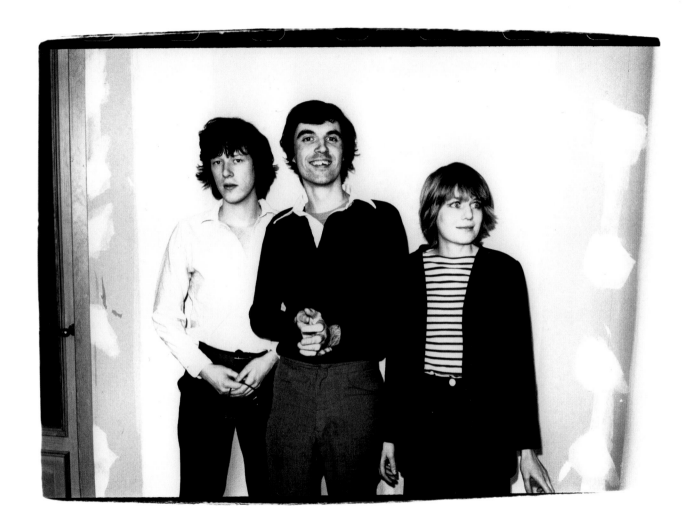

Chris Frantz, David Byrne and Tina Weymouth, ca. 1976-79

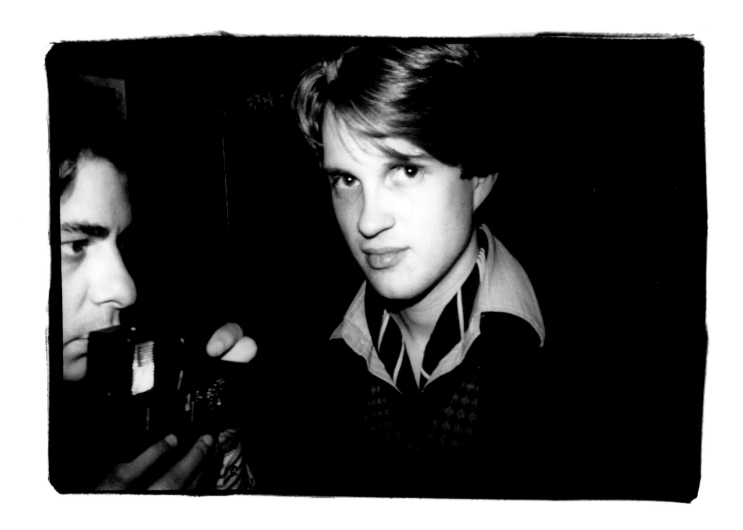

Bob Colacello and Jason McCoy, ca. 1976-79

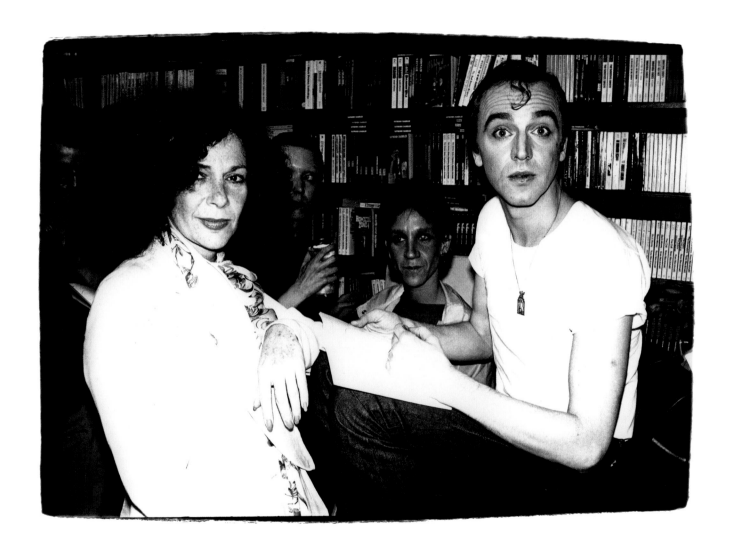

Ruth Kligman, Rene Ricard and Others, 1979

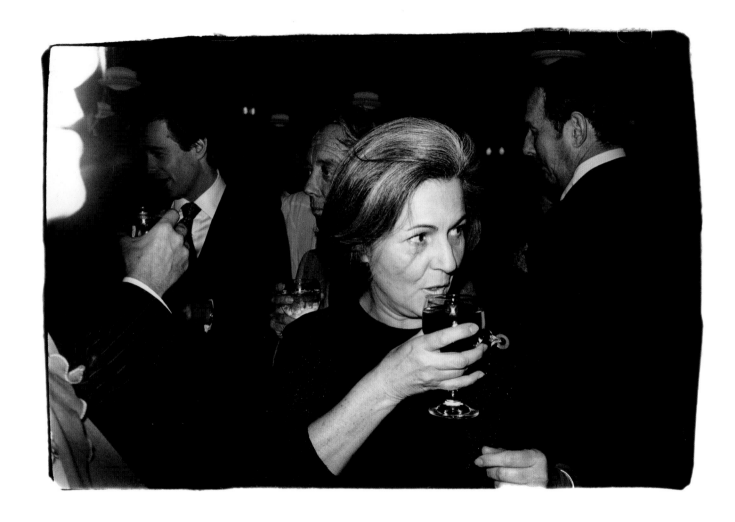

Boaz Mazur, Camilla McGrath, and Fellow Partygoers, ca. 1976-79

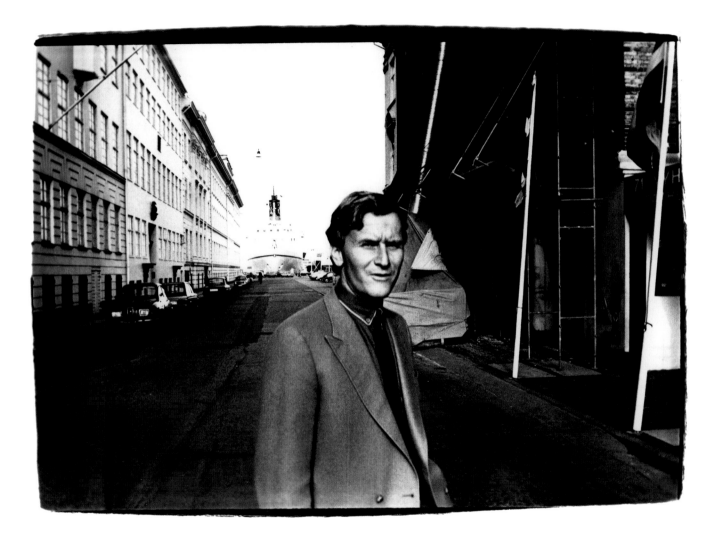

Thomas Ammann, 1978

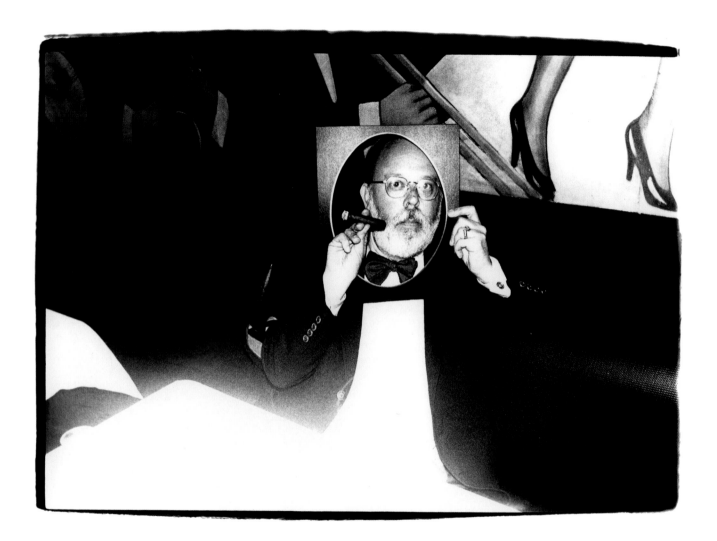

Henry Geldzahler, ca. 1976-79

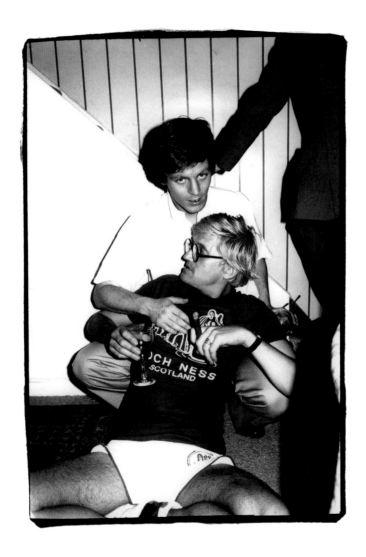

David Hockney and John Abbott, ca. 1976-79

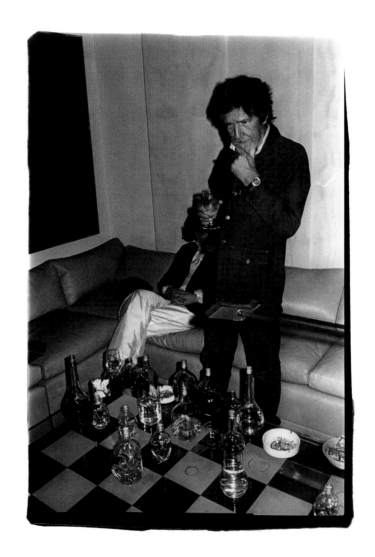

John Cage, ca. 1976-79

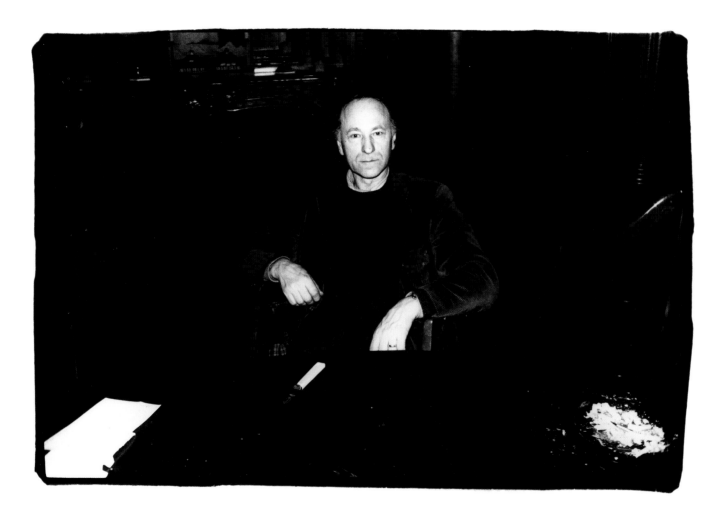

Jonas Mekas, 1978

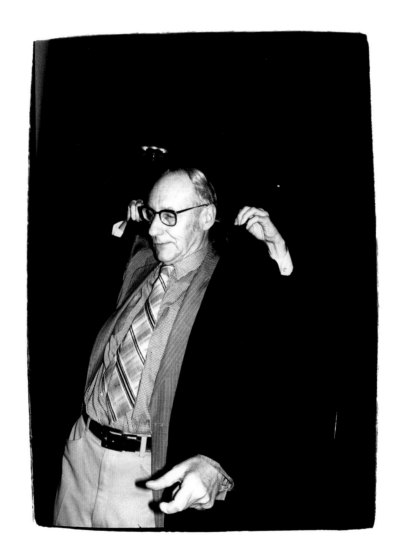

William Burroughs, 1980

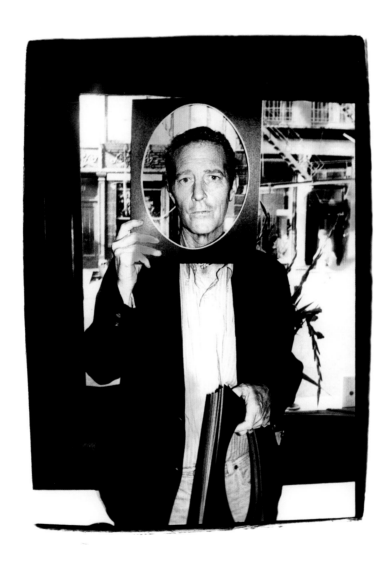

Bob McBride, ca. 1976-79

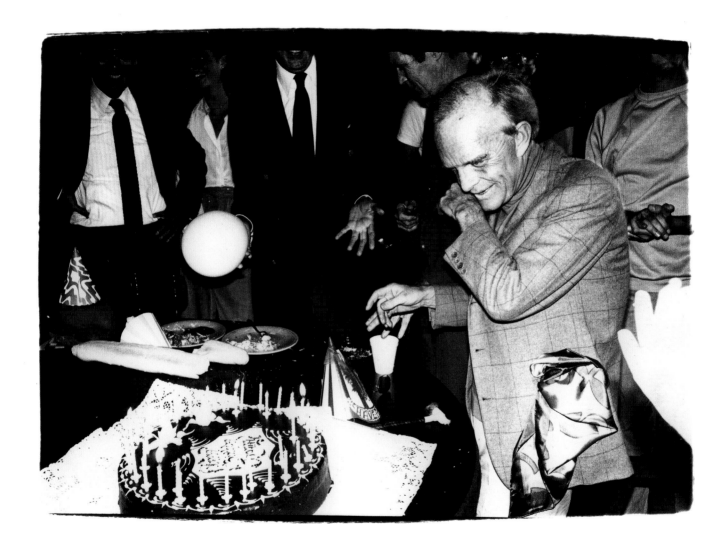

Truman Capote, ca. 1976-79

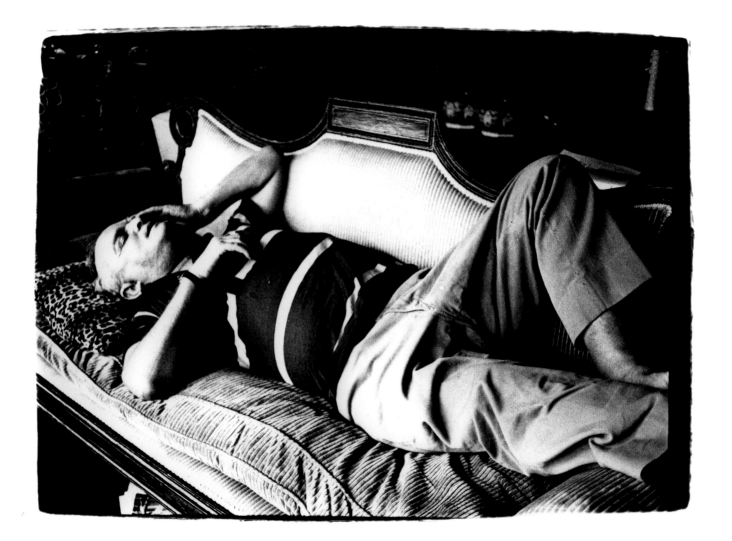

Truman Capote, 1978

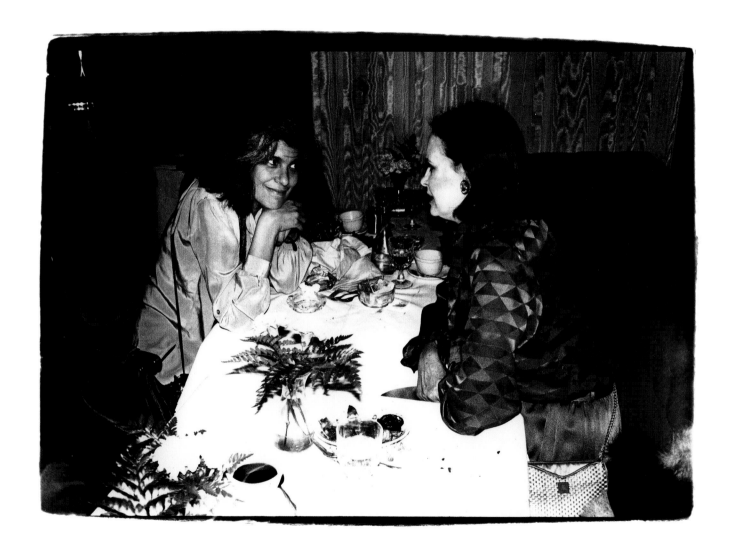

Susan Sontag, Gloria Vanderbilt, ca. 1976-79

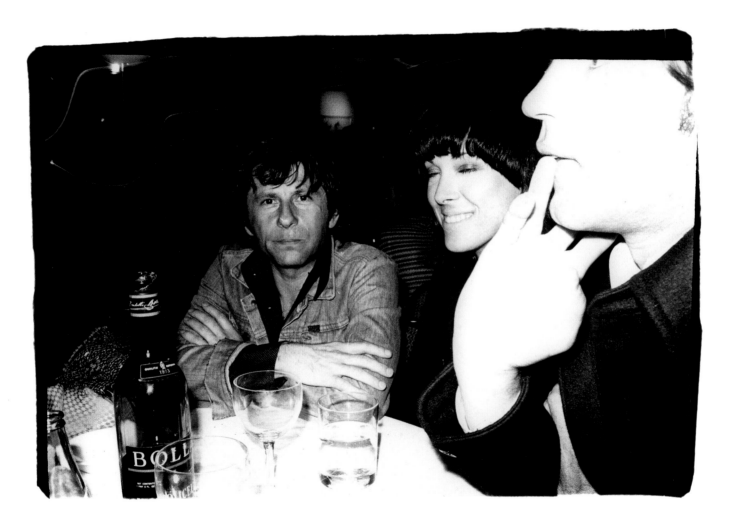

Roman Polanski and Fellow Partygoers, ca. 1977

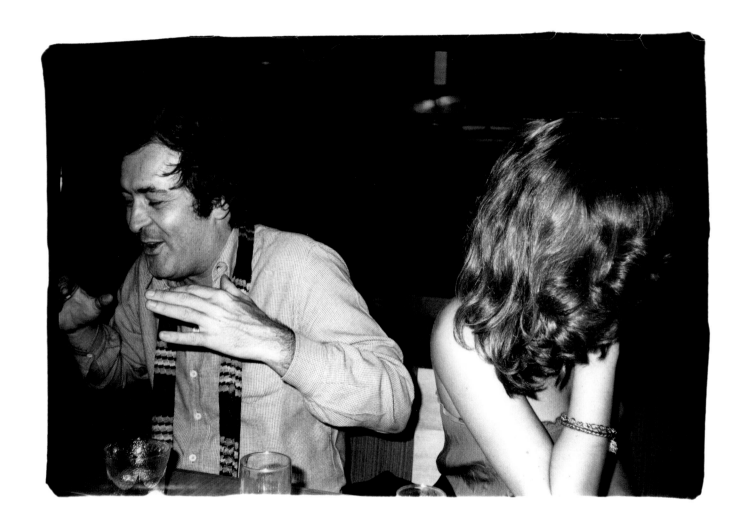

Bernardo Bertolucci and Fellow Partygoer, ca. 1976-79

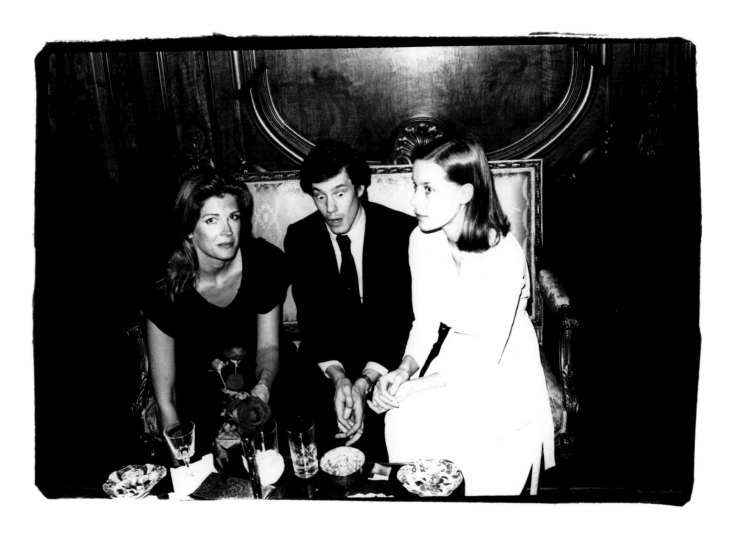

Candice Bergen and Fellow Partygoers, ca. 1976-79

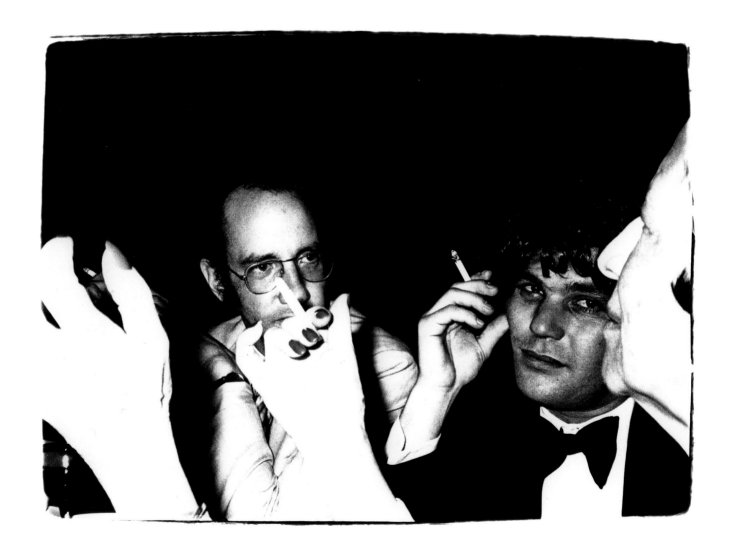

Jann Wenner, Diana Vreeland and Fellow Partygoer, 1978

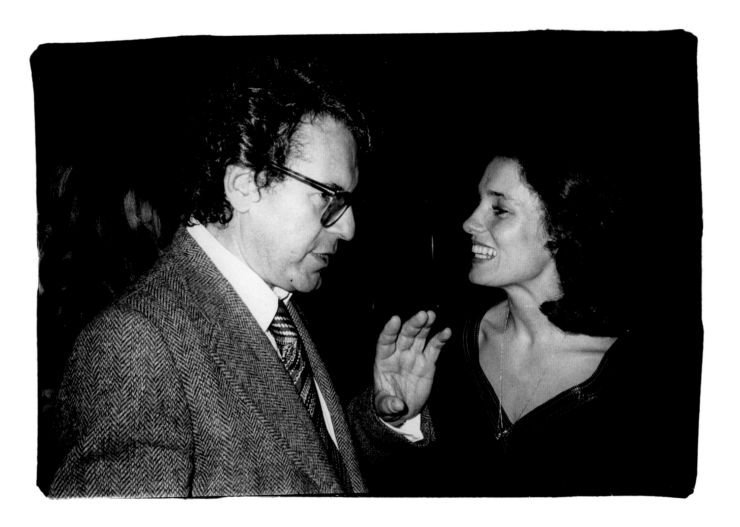

Milos Forman and Margaret Trudeau, 1977

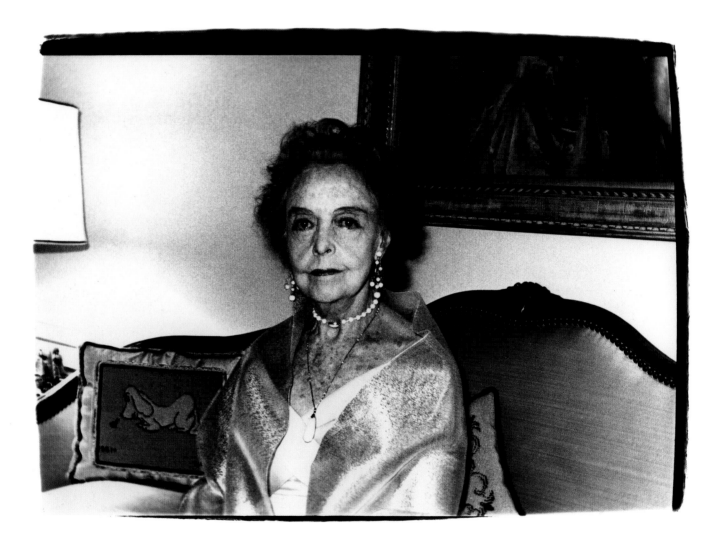

Lilian Gish, 1978

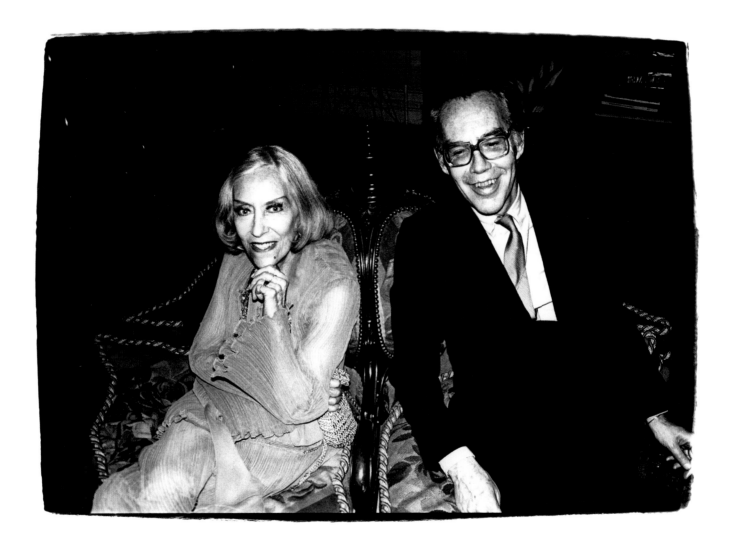

Gloria Swanson and William Duffy, ca. 1976-79

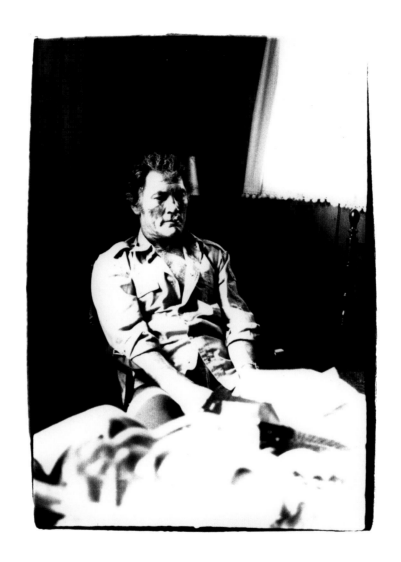

Jack Palance, 1978

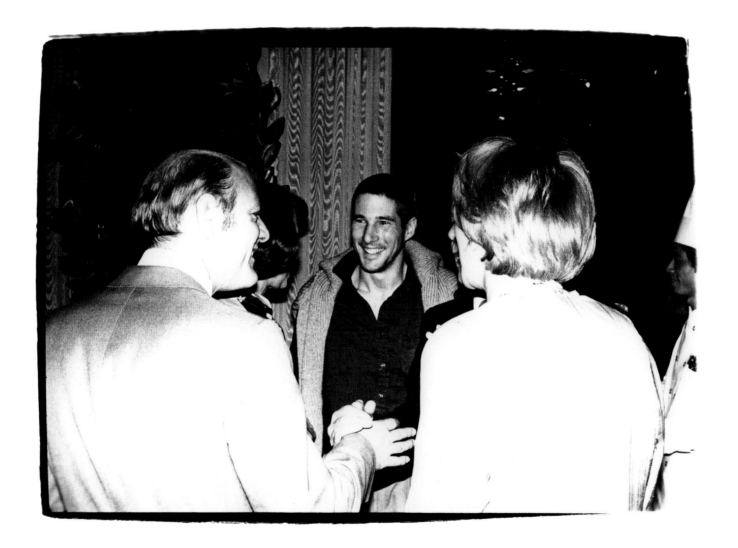

Barry Diller, Richard Gere and Friends, ca. 1979

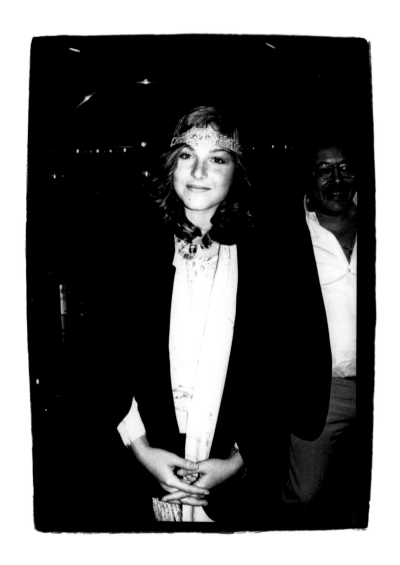

Tatum O'Neal, 1979

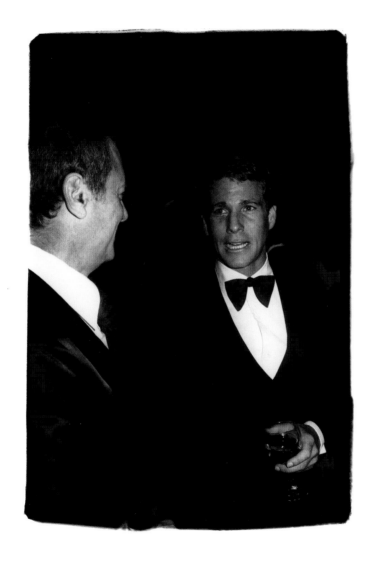

Tony Curtis and Ryan O'Neal, ca 1976-79

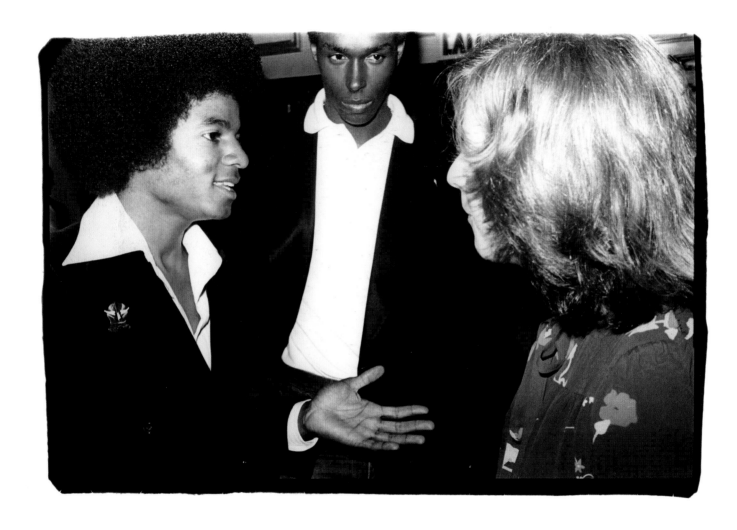

Michael Jackson, Sterling St. Jacques and Catherine Guinness, ca. 1976-79

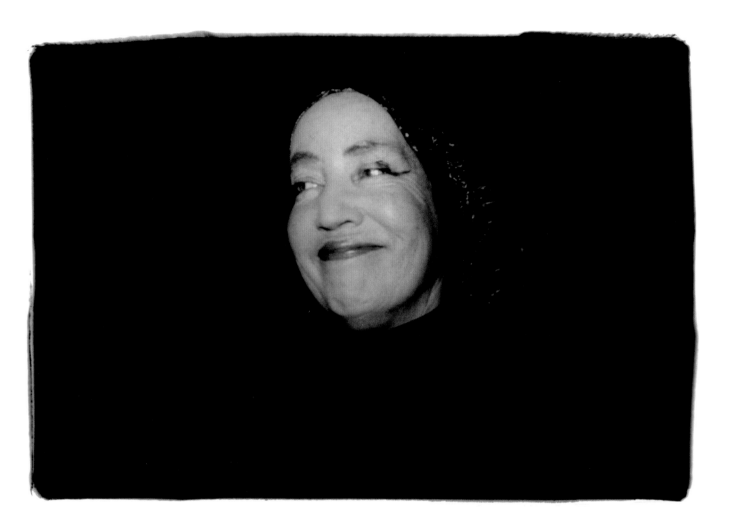

Edie Beale, ca. 1976-79

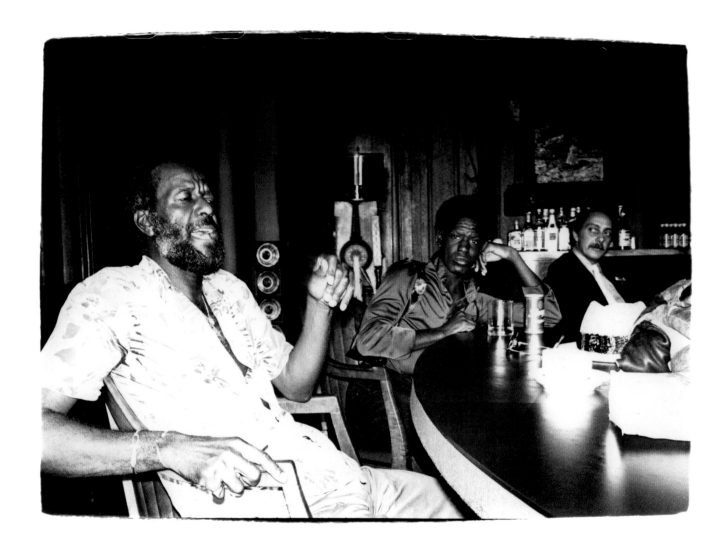

Famous Amos and Friends, 1979

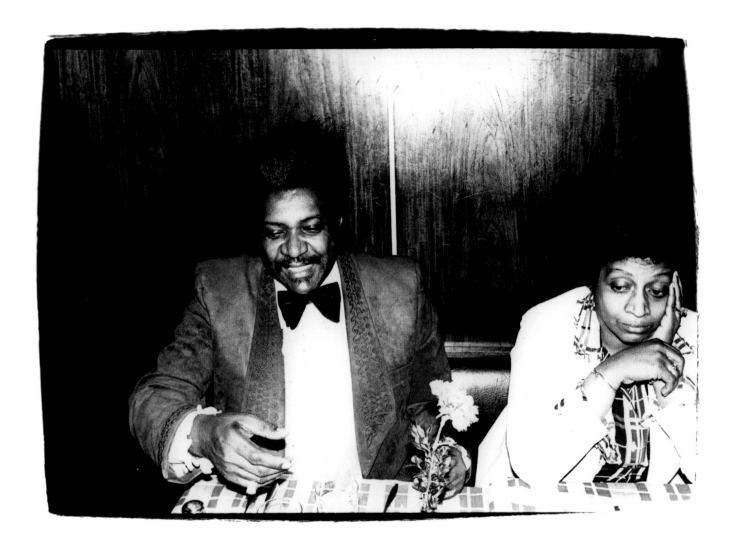

Don King and Friend, 1979

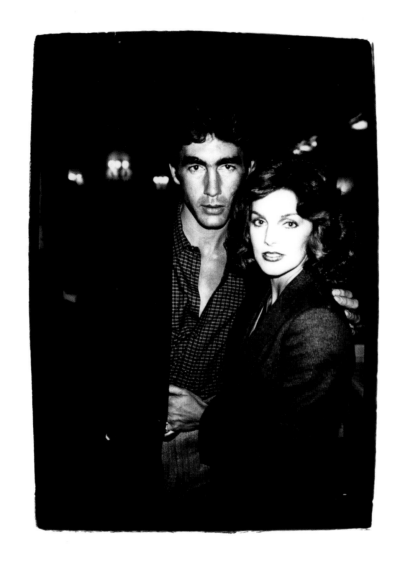

Priscilla Presley and Friend, 1979

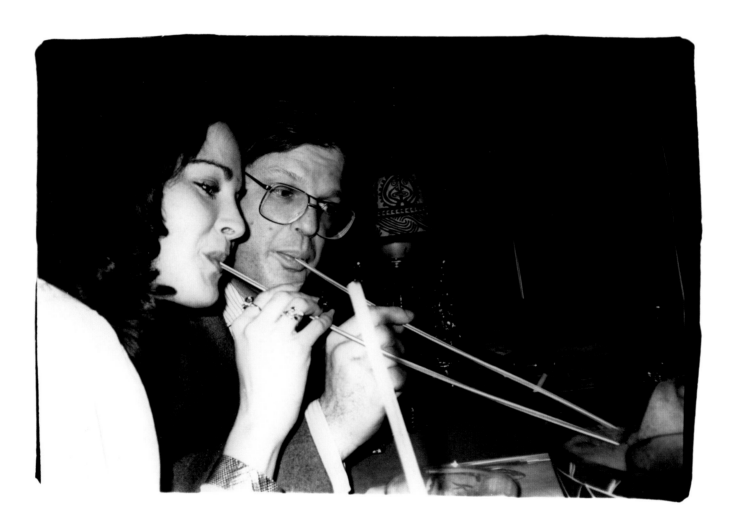

Richard Weisman and Friend, 1978

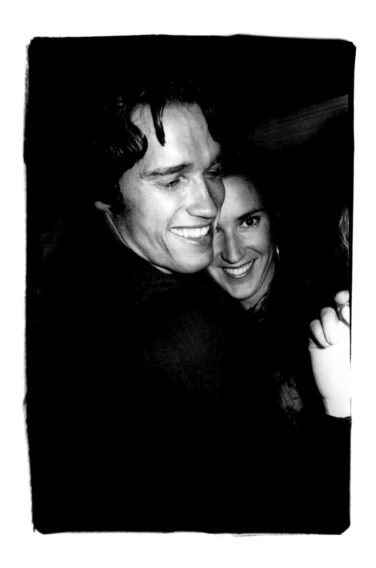

Arnold Schwarzenegger and Friend, ca. 1976-79

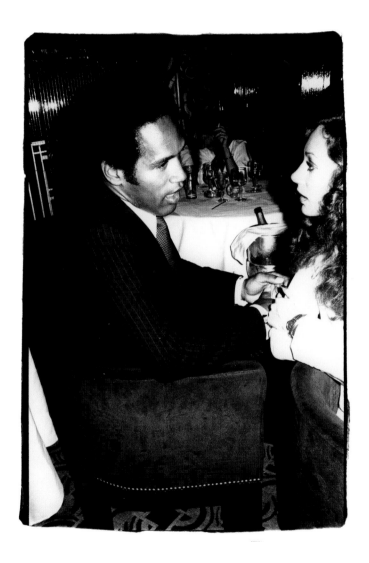

O.J. Simpson and Marisa Berenson, ca. 1976-79

Amy Carter, 1976

Jade Jagger, ca. 1976-79

Two Boys, ca. 1976-79

John Paul Getty III and Friends, ca. 1976-79

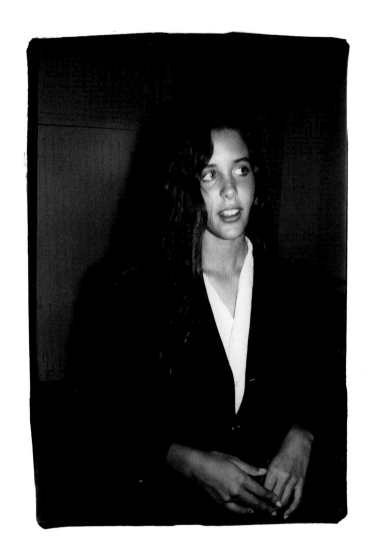

Fernanda Eberstadt, 1977

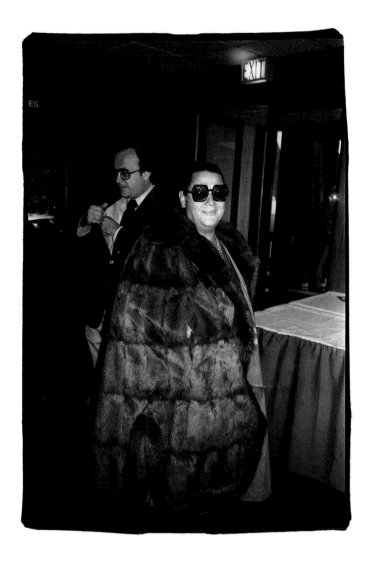

Elaine Kaufman, ca. 1976-79

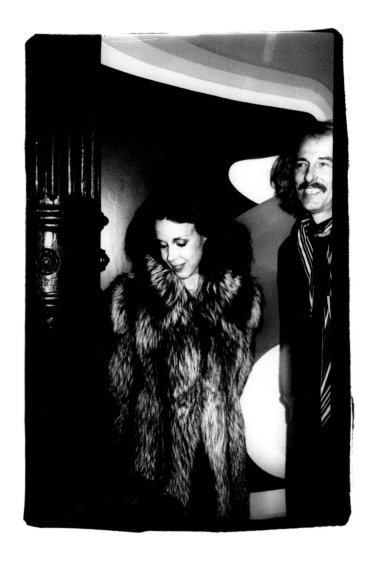

Isabelle Eberstadt and John Phillips, ca. 1976-79

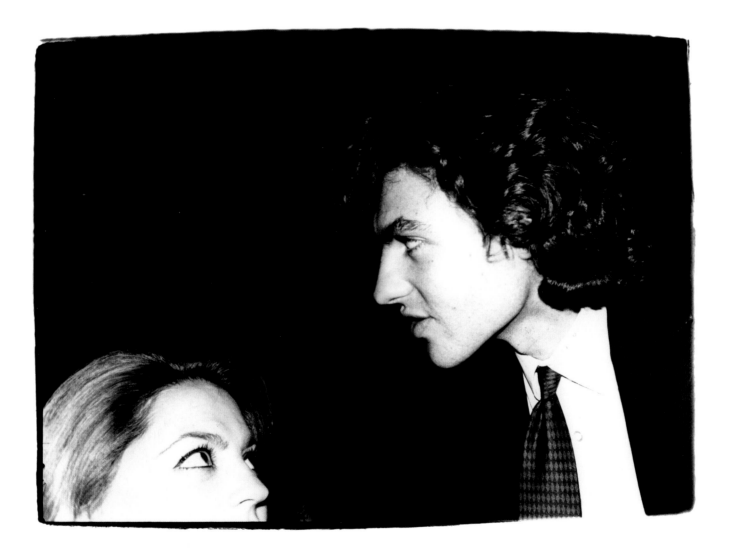

Hubertus von Hohenlohe and Friend, ca. 1976-79

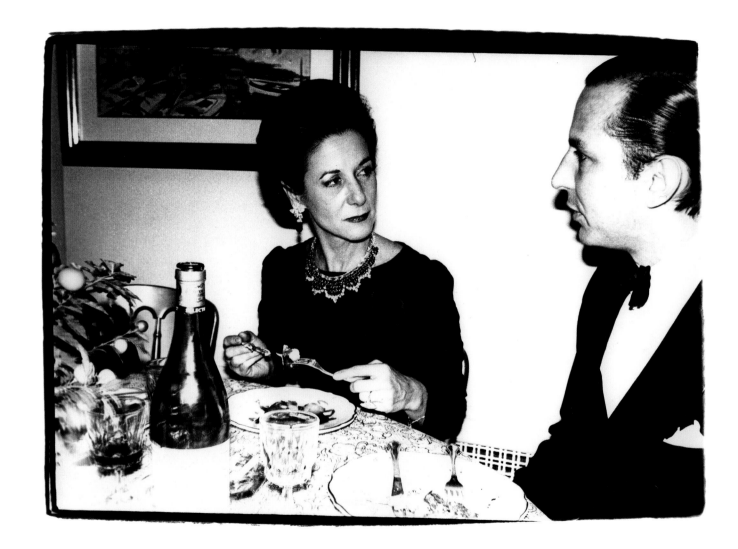

Eliza Moreira Salles and Fred Hughes, ca. 1976-79

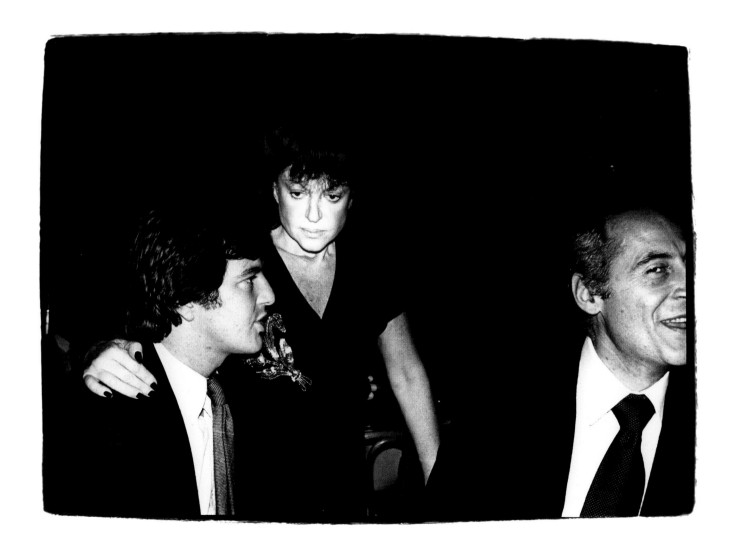

Lupo Rattazzi, Regine and Franco Rossellini, ca. 1976-79

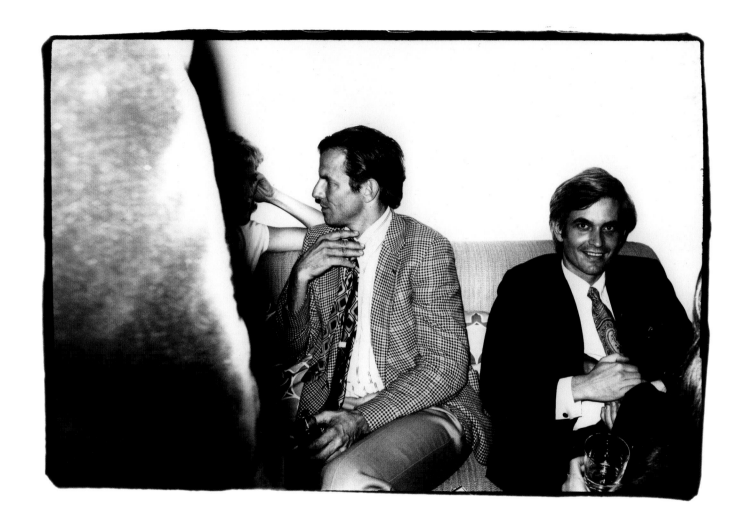

Peter Beard and Jay Mellon, ca. 1976-79

William Zeckendorf, ca. 1977

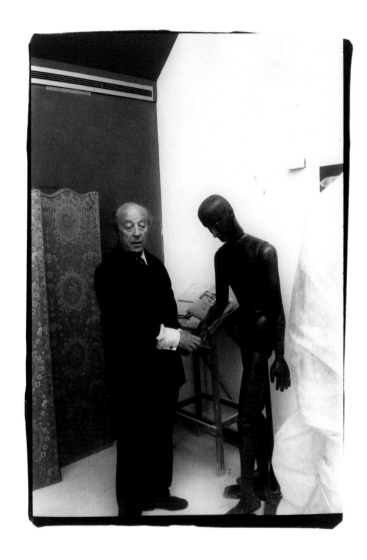

Baron Philippe de Rothschild, ca. 1976-79

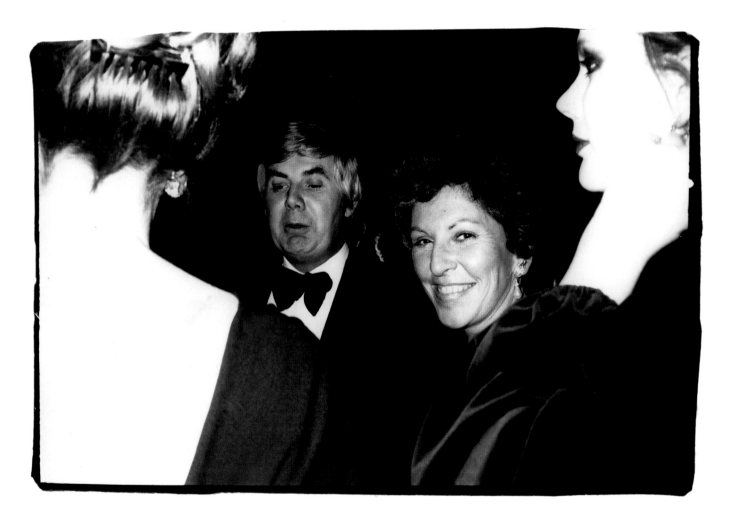

John Fairchild, Geraldine Stutz and Norris Church, ca. 1976-79

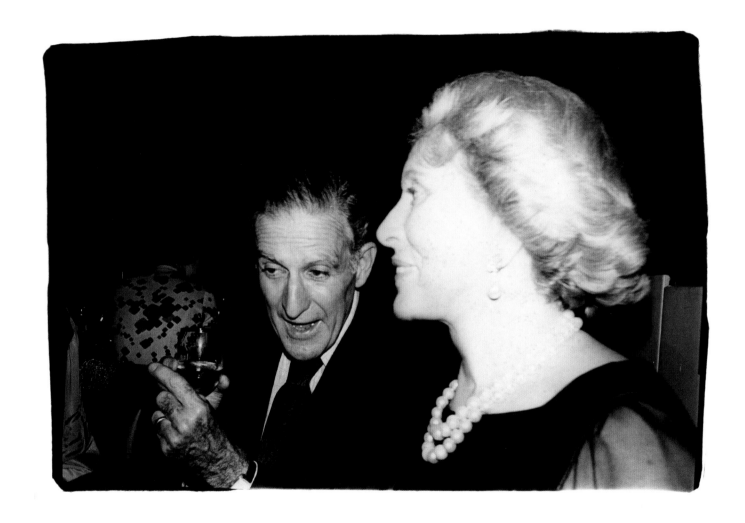

Brendan Gill and Estee Lauder, ca. 1976-79

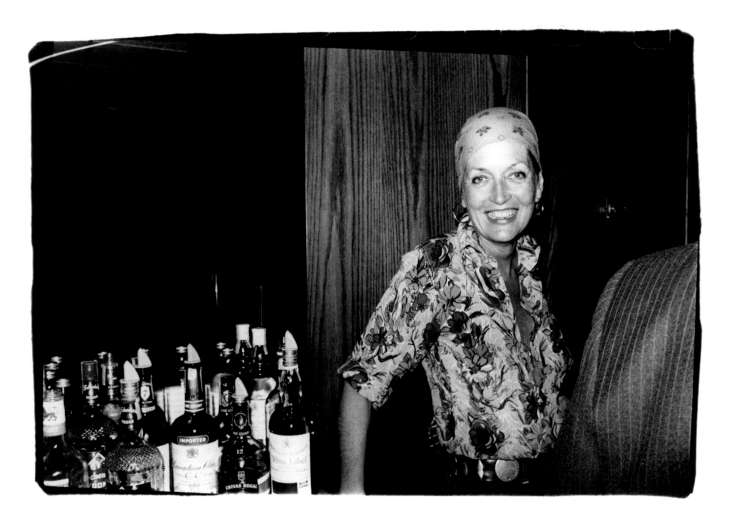

Maxine de la Falaise, ca. 1976-79

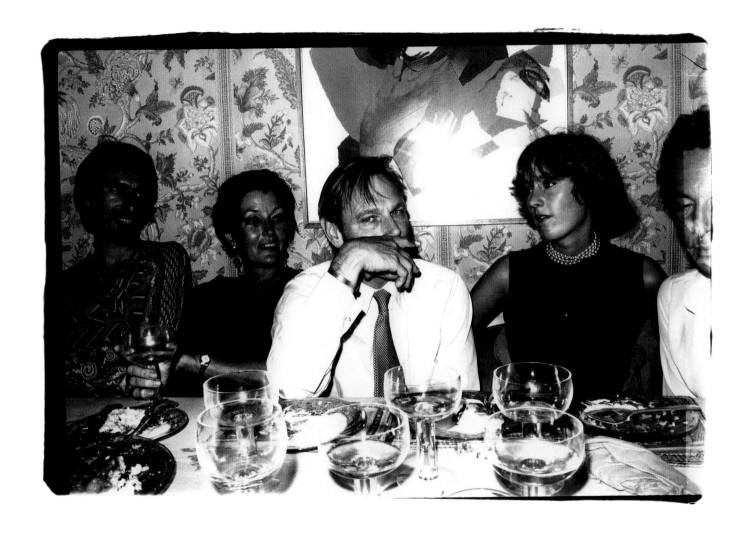

John Phillips, Billy Rayner, Catherine Guinness and Friends, ca. 1976-79

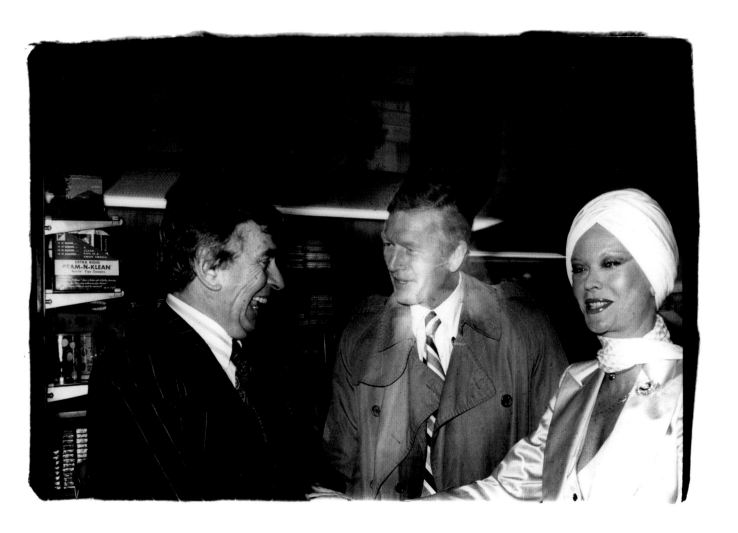

Gore Vidal, John Lindsay and Monique Van Vooren, ca. 1976-79

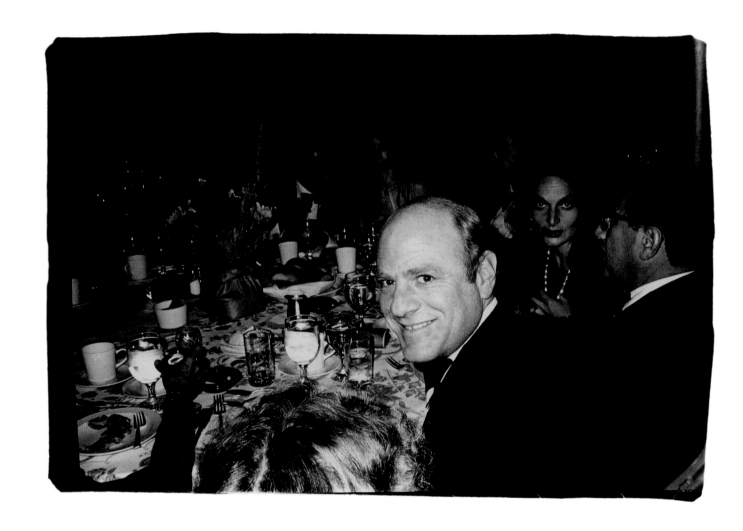

Barry Diller, Henry Kissinger, Diane Von Furstenberg and Fellow Partygoers, ca. 1976-79

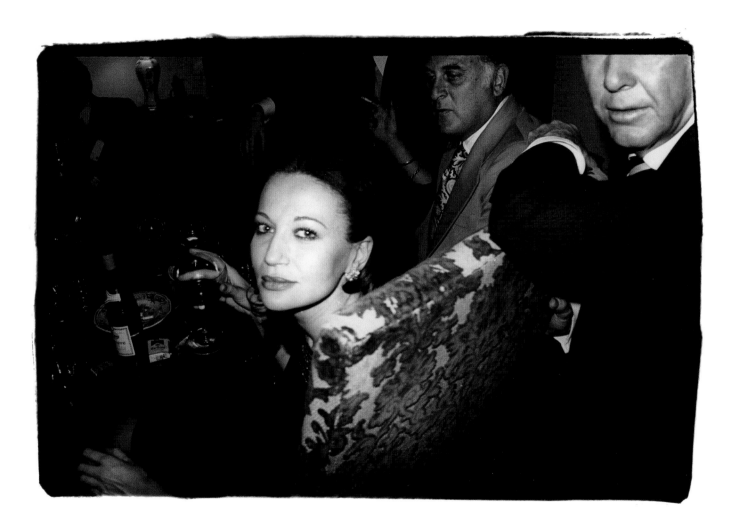

Partygoers, ca. 1976-79

Sondra Gilman, ca. 1976-79

Saratoga, ca. 1976-79

Cowboy Boots, 1978

Boots, 1978

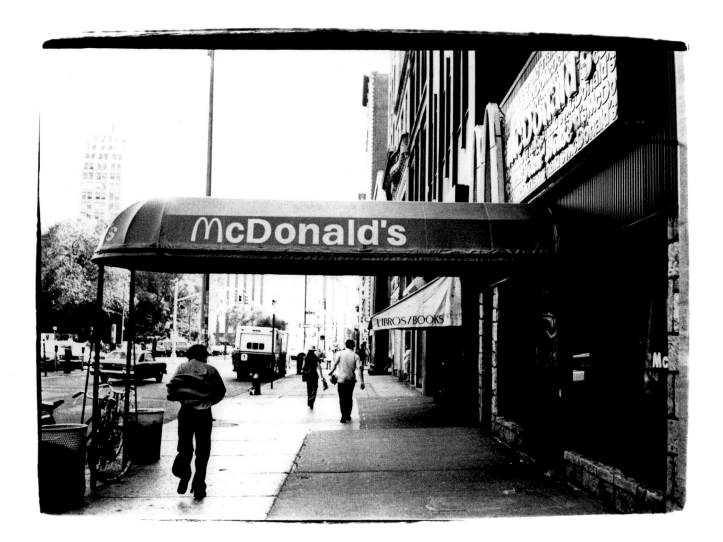

Union Square McDonald's, 1978

Wine Bottles, 1979

Table Top, ca. 1976-79

Flowers, ca. 1976-79

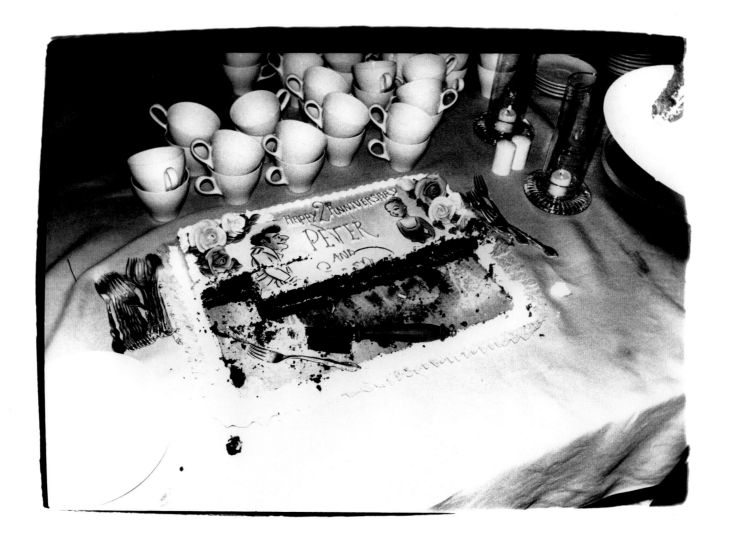

Anniversary Cake, 1979

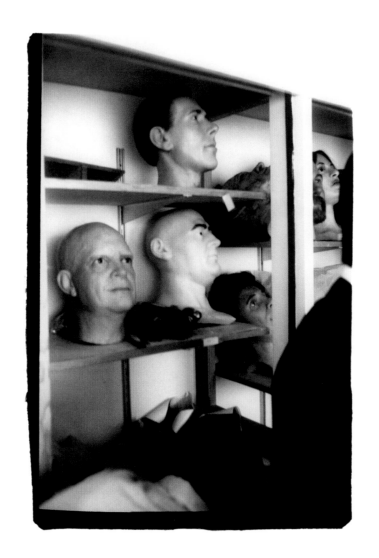

Heads, ca. 1976-79

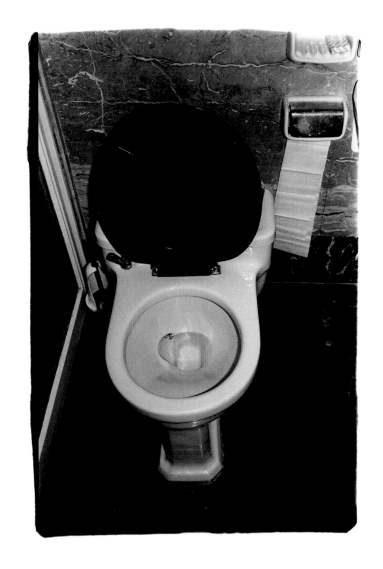

Toilet, ca. 1976-79

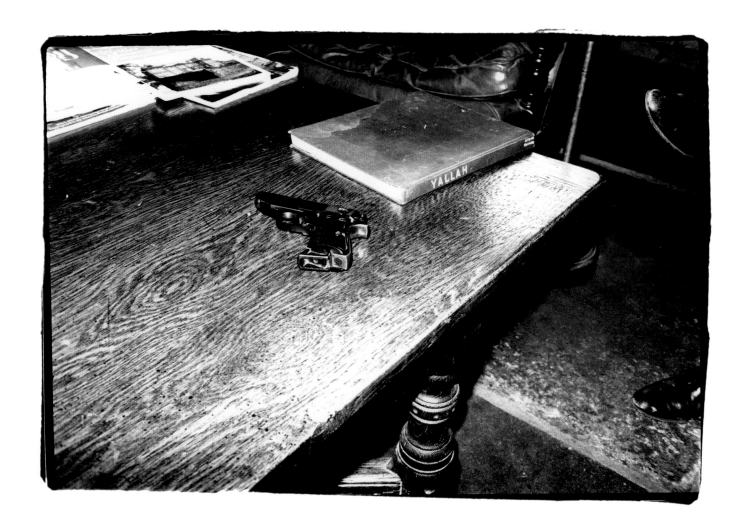

Gun, Montauk, ca. 1976-79

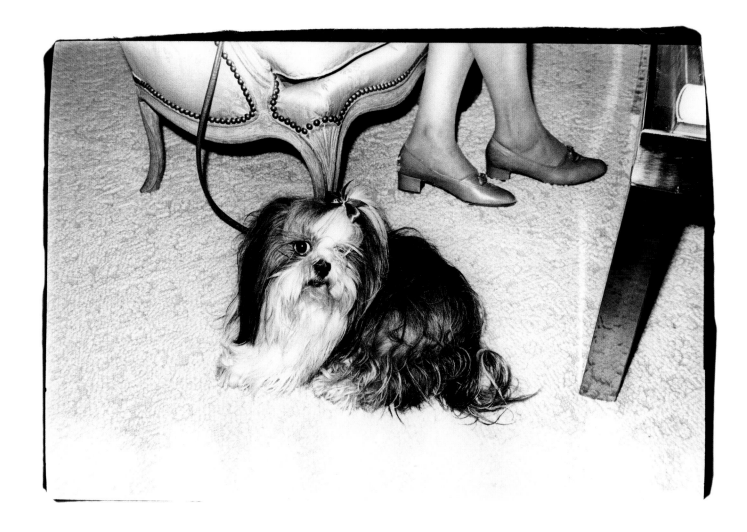

Dog, ca. 1976-79

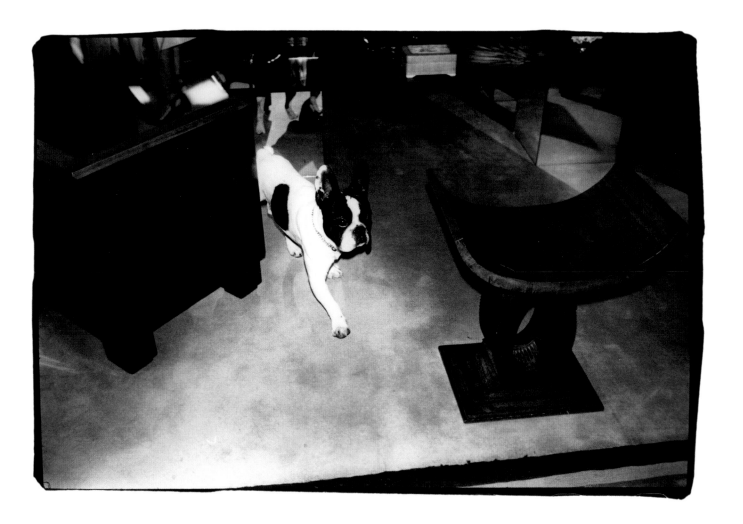

Moujik (Yves Saint Laurent's Dog), ca. 1976-79

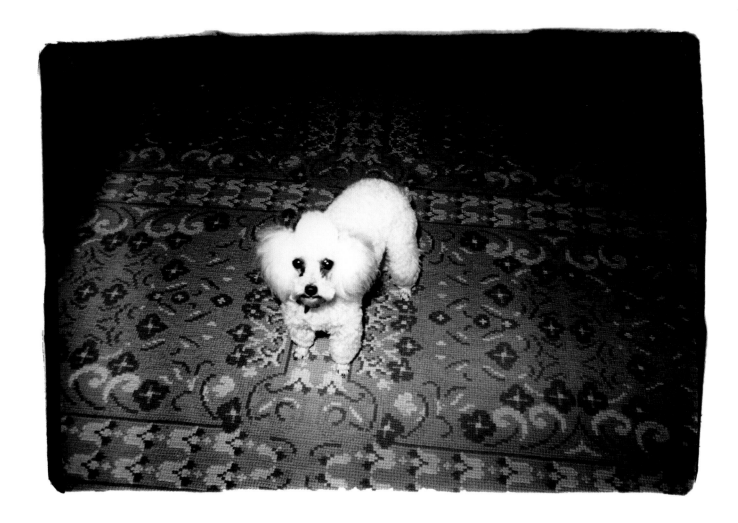

Dog, ca. 1976-79

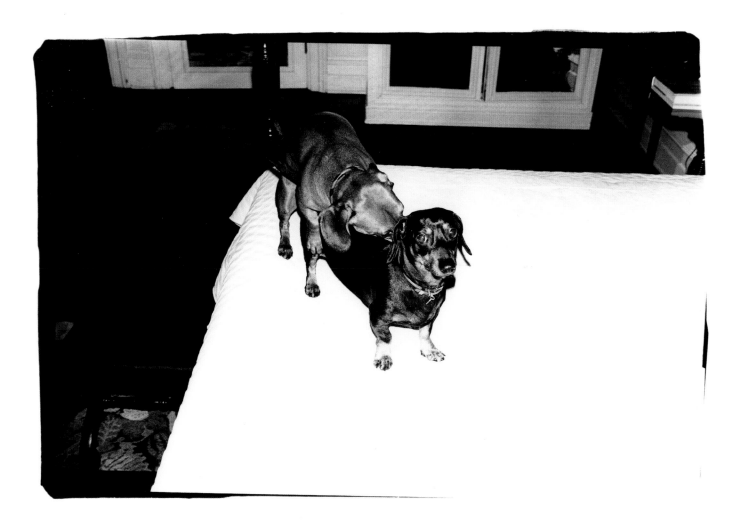

Amos and Archie (Andy's Dogs), 1978

Published on the occasion of the exhibition "Andy Warhol: Unexposed Exposures" at Steven Kasher Gallery, March 2 – April 3, 2010. First Edition 2010. © 2010 for the images: The Andy Warhol Foundation for the Visual Arts, Inc. © 2010 for the essay by Bob Colacello. © 2010 Steidl Publishers and Steven Kasher Gallery. Picture selection by Bob Colacello, Timothy Hunt, and Steven Kasher. Book design by Bernard Fischer, Steven Kasher and Gerhard Steidl. Printing by Steidl, Göttingen. Published by Steidl and Steven Kasher Gallery, Steidl Publishers, Düstere Str. 4, 37073 Göttingen, Germany. www.steidlville.com www.steidl.de Steven Kasher Gallery, 521 West 23rd Street, New York, NY 10011, USA. www.stevenkasher.com. ISBN 978-3-86930-116-7. Printed in Germany